COLLINS
CONCISE GUIDE TO
PHOTOGRAPHY

Collins Concise Guide to Photography is a complete portable pack of all the information most photographers are ever likely to need. This working manual is the distillation of years of professional experience into a form which can readily be understood, both visually and verbally. It aims, quite simply, to present the essentials of photography in compact and *usable* form. In easy-to-follow sections, every practical aspect of indoor and outdoor photography is covered in a variety of situations, demonstrating how the best results can be achieved.

Designed for immediate and practical use in a given situation, *Collins Concise Guide* begins with detailed information on light and lighting conditions, both natural and artificial, indoors and out. Thus the photographer can master techniques for all occasions, from photographing clear skies, fog or mist to capturing memorable moments such as a rainbow or a flash of lighting. Equally, essential instruction is given for shooting indoors, in a studio or an interior location. The *Guide* identifies all potential problem areas and shows how to overcome them quickly and easily.

Sections on film, which to use and why, cameras and accessories help give the photographer a thorough working knowledge. Special subjects, including candid and formal portraits, architecture, wildlife, sports and still-life, are examined in depth to show exactly how to achieve the result desired. So that the essential information can be quickly accessible, all the technical details not directly relevant to the shoot in hand are contained in a series of technical checklists, fully integrated with line drawings, at the end of the book. *Collins Concise Guide* provides instant access to sometimes complex information on topics such as the use of filters, exposure measurements, as well as practical advice on the handling, care and cleaning of cameras. Key facts are presented in easy-to-follow reference boxes.

Michael Freeman is a professional photographer, based in London, with many years' experience, specializing in reportage, studio, travel and wildlife photography. He is the author of several successful books, including *The 35mm Handbook, The Manuals of Indoor and Outdoor Photography, Wildlife and Nature Photography, Photography: Techniques and Materials* and *The Studio Manual*. His work is also featured extensively in Time-Life Books, GEO and other magazines.

COLLINS
CONCISE GUIDE TO
PHOTOGRAPHY

MICHAEL FREEMAN

COLLINS

First published 1984 by
William Collins Sons & Co Ltd
London · Glasgow · Sydney
Auckland · Toronto · Johannesburg

Copyright © 1984
Robert Adkinson Limited

ISBN 0 00 411939 8

Designed and produced by
Robert Adkinson Limited, London
Editorial Director
Clare Howell
Editor
Hilary Dickinson
Design
Rose & Lamb Design Partnership
Illustrations
Rick Blakely, Sue Rose, Anne Lamb,
Rob Shone

Phototypeset by Dorchester Typesetting Group Ltd, Dorchester
Illustrations originated by Newsele s.r.l., Milan
Printed and bound in Great Britain by
William Collins Sons & Co Ltd, Glasgow

All photographs by the author with the
exception of 104, 105 (top): All-Sport

Contents

Introduction

The object of this book is simple enough – to present the essentials of photography in as compact and usable a form as possible. In every section of the guide, it has been the author's intention to present information in a form most immediately of use to the practising photographer. Thus the first priority of the book has been the taking of pictures rather than the study of equipment.

Admittedly, photography does acquire fascinating new technology daily, in emulsions, processing, camera mechanics and, especially, electronics. It can often seem to the average photographer that more and more technical knowledge is necessary to take better photographs. A typical lens reflex of advanced design, for example, has several different exposure methods and different presentations of shutter, speed and aperture.

Such choice may indeed be valuable to the user, but it also demands some degree of technical knowledge and even encourages the view that photography is dominated by equipment. Truly successful photography, however, is just as likely to depend on an appreciation of the qualities of certain types of light, of how to take a portrait, or how to master a design technique which can be used with an intricate landscape.

Too great an emphasis on equipment and technical knowledge

tends to produce results which show competence rather than imagination. Technical expertise should be a means of converting images to film, but the images themselves should be the product of the photographer's visual sense and imagination. It seems to me, then, that a sense of proportion needs to be restored in the present book and I have therefore tended to treat equipment more as the tools of the craft rather than the source of photographs.

This does not mean that photographic technology has been relegated to a minor role; far from it, since only by knowing the full range of equipment available can the photographer select the best for the job. What is different in this book is the ordering of the information. The guide begins with the conditions for successful photography; so that the essential information for any situation can be quickly accessible, all the technical details which are not immediately relevant to shooting are contained in a separate section at the end of the book. This has been done to separate side-issues from main priorities, making this guide especially useful when photographs are actually about to be taken. This book is, after all, intended to be a concise working manual.

Michael Freeman

LIGHT/Natural light: Clear skies

Natural light has one single source – the sun – but its variety is enormous. How it appears at any particular time and place depends mainly on the position of the sun and on the weather. The simplest conditions, which give the most predictable lighting, are a clear sky and direct sunlight. The sharp, distinct shadows under a bright sun help to make scenes appear crisp and detailed, and the contrast between different colours is sharpened. In addition, however, the contrast between the shaded and sunlit parts of a view is increased, which may make it impossible to record all the details in both on film.

The angle of the sun Depending on the time of day, the season, and the latitude, the sun can light a scene from any angle between horizontal and vertical. This affects the brightness and colour, but more important, it affects the aesthetic qualities of a photograph through texture, contrast, and hue. For most subjects, the light from a low sun is conventionally more attractive than when it is high, but with imagination it is possible to find good creative uses for *all* kinds of light.

A low sun shines through so much atmosphere close to the horizon that the dust and water-vapour scatter away more of the shorter, bluer wavelengths than any other, so that it appears orange, and sometimes even red. This same scattering makes a clear daytime sky appear blue, tinging midday shadows surprisingly strongly.

Low sun For the first and last few hours of the day, sunlight is warmly coloured but not very bright; its qualities change rapidly and are hard to predict. Because it strikes the landscape at a sharp angle, it gives a choice of lighting, depending on the position of camera and subject.

Behind the camera
☐ Rich, warm, saturated colours
☐ No strong shadows
☐ Even lighting for tall subjects, such as trees and buildings

Cross-lighting
☐ Warm colours
☐ Long, definite shadows
☐ Gives strong modelling to shapes
☐ Emphasizes texture in flat landscapes
☐ Heightens relief in rolling landscapes

Back-lighting
☐ High contrast; silhouettes in some situations
☐ Lens flare likely
☐ Muted colours; sometimes no colour
☐ Strong reflections in water

High sun Technically, photography is easy in the brightness of a midday sun – high shutter speeds and small apertures can be used, even with slow film. Aesthetically, however, the strong deep shadows that it casts *underneath* subjects often confuse the image, while contrast can be too high for colour transparencies.
☐ Flat landscapes dull, lacking in detail
☐ Portraits unflattering
☐ Stark shadows and high contrast sometimes good for graphic subjects that have strong tones, patterns or colours, such as modern buildings, swimming pools, beaches
☐ The shade may be better for portraits because of its lower contrast, but a clear sky gives a blue cast; use an 81EF filter or similar to compensate

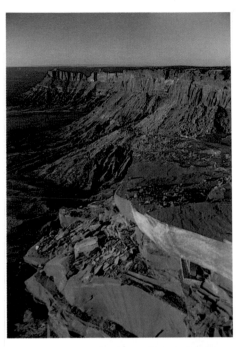

With the sun almost directly behind the camera, the colours are intensely rich and warm, appropriate for the reddish rocks of this cliff in Eastern Utah (left).

Back-lighting, whether directly against the sun or against its reflection, can create silhouettes that are an attractive way of treating subjects with distinctive outlines, such as this spoonbill (below).

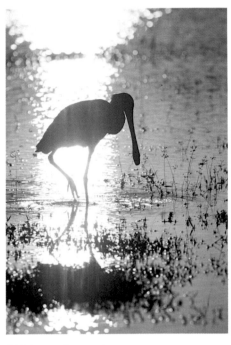

A high noonday sun, here lighting part of the waterfront at Benares, gives high contrast, useful for emphasizing simple shapes and lines (left).

Natural light: Clouds

In most parts of the world, completely clear skies are less common than some degree of cloud cover, and it is the changeability of weather that brings real variety to daylight. Each type of atmospheric condition – haze, mist, fog, low clouds, high clouds, and so on – produces its own distinctive quality of light, ideal for some subjects, difficult for others.

Changing the light The most obvious thing that clouds do is to diffuse the light. In other words, they spread it over a greater area of the sky. Thin, high clouds have only a slight diffusing effect; the sun remains clear enough to cast shadows, but these are softened. At the other extreme, low, continuous cloud cover removes all definite shadows and flattens contrast. The more that sunlight is diffused, the lower the light level, and the meter reading on an overcast day that threatens rain may be 4 stops less than in bright sunlight.

Clouds also act as reflectors, just as white walls do in a studio, and if a bank of fair-weather cumulus lies opposite a clear sun, shadows in the subject are likely to be filled in quite noticeably. White clouds on a sunny day also reduce the blue cast to shadows.

Generally, in overcast weather the colour temperature is slightly higher, so that there is a tendency for photographs under cloudy skies to appear very slightly cool. A straw-coloured filter, such as an 81A, balances this.

Changing the landscape Clouds can be a spectacular addition to a landscape, particularly when they have distinctive, individual shapes or when, in mountains and hills, they touch the ground. Placing the horizon low in the frame emphasizes clouds as subjects, and an isolated thunderhead or the tattered remnants of a recent storm can make a strong, effective image with maximum impact.

A polarizing filter strengthens a pattern of clouds by darkening the clear sky (an orange or red filter does the same with black-and-white film). A wide-angle lens gives a good coverage of the sky and good contrast. For thicker cloud cover, a neutral graduated filter (see page 48) restores the balance between the light sky and darker ground. For spectacular sunrises and sunsets, scattered clouds are the best ingredient, particularly when they are at different heights.

Thin cloud
- ☐ Softens shadows without destroying them
- ☐ Reduces contrast slightly
- ☐ Good for portraits

Scattered clouds
- ☐ Fill in shadows slightly
- ☐ Reduce exposure by about 2 stops when they pass in front of the sun
- ☐ Make strong subjects in a landscape view
- ☐ Vividly reflect the warm colours of sunrise and sunset

Overcast sky
- ☐ Kills shadows and flattens contrast
- ☐ Usually appears washed out in a photograph if the exposure is set for the landscape (use a graduated filter)
- ☐ Good for clear views of complicated details, such as tangled tree roots and patterns of leaves and branches

How clouds reduce light As an aid to exposure, compare the cloud cover with these four conditions. The light from the first is one stop darker than from a clear sun, and so on:

Thin high cloud	Cloudy bright	Moderately overcast	Rainclouds
Darker than direct sunlight: 1 stop darker	2 stops darker	3 stops darker	4 stops darker

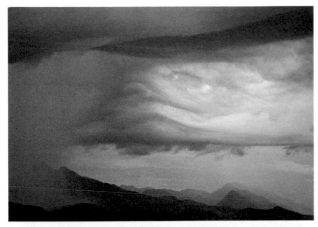

The shape and variability of stormclouds make them interesting potential material for a landscape shot. Sheets of rain connect the sky to the land, and so help to unify the picture. Calculate exposure directly from the sky.

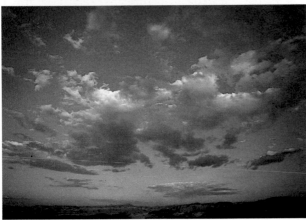

Distinctly shaped clouds, and particularly those that are different in tone from the sky, can make strong components in a landscape. A low horizon directs attention to them while retaining a frame of reference.

These two identical views show the basic effects that average cloudiness has on the landscape. The pale tone of the sky shifts the graphic weight downwards, details are rendered more through the tones of the subject than through shadow, and the over-all colour cast is cooler.

Natural light: Haze, mist and fog

Haze, mist, and fog all thicken the atmosphere and obscure the distance. They also reduce contrast and mute colours, and although there are many scenes that would look better if the sky were crisp and clear, the great value of these softer, pastel conditions is that they can make evocative landscapes. Just because they fade out the background, they increase the sense of depth and distance in a view.

Haze particles are much smaller than the water droplets in mist and fog, and so their effect is not so strong, except occasionally in very hot, muggy weather. However, they do scatter light selectively – that is, some colours are filtered out more than others. The short ultra-violet waves are the most affected, and although these are invisible to our eyes, film is quite sensitive to them. The result is that, on colour film, haze appears bluish, which can be a nuisance. A colourless ultra-violet filter helps to correct this, and has the added advantage of protecting the front of the lens from dust and scratches.

Telephoto lenses *seem* to suffer more than other focal lengths from haze, but only when they are used for long-distance views that magnify more of the atmosphere; a UV filter with a slight yellowish tinge helps. The most effective haze-cutter of all is a polarizing filter – provided that the camera is pointed at right angles to the sun. With black-and-white film, a red filter reduces the effect of haze while a blue filter enhances it. Infra-red film is practically immune to haze, but it also gives rather unusual images for general photography.

To exaggerate haze, as in the photograph (opposite centre), shoot towards the sun with an unfiltered telephoto lens. Back-lighting tends to bring out shapes through partial silhouettes.

Mist and fog have a much more obvious effect, sometimes so extreme that hardly anything can be seen. Wisps and rolling banks of fog can be especially dramatic: worth exploiting whenever they occur. Early-morning mist near lakes and the sea usually clears during the morning as the sun warms them; the moment when it

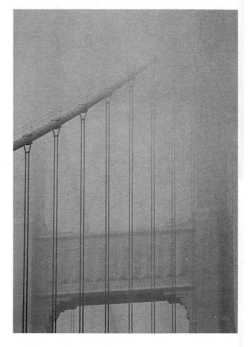

With a deep subject, such as San Francisco's Golden Gate Bridge, fog tends to remove the background, separate the planes, and so simplify and abstract the image. The effect often changes minute by minute.

begins to clear is often the best for photography. Unlike with haze, filters have no effect.

Haze
- ☐ Exaggerates sense of distance
- ☐ Weakens shadows and contrast
- ☐ On colour film, increasingly blue at a distance
- ☐ Weakens colours and tones of distant views

Mist and fog
- ☐ Unpredictable and very changeable
- ☐ Give strongly impressionistic images
- ☐ Severely reduce contrast and colour
- ☐ Make foreground subjects stand out clearly, often in silhouette

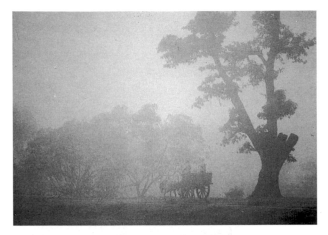

When all the elements in the picture are at a common distance, fog has the effect of degrading the image to produce a gentle silhouette. When the fog clears or thickens, timing is important to catch the right subtlety of outline.

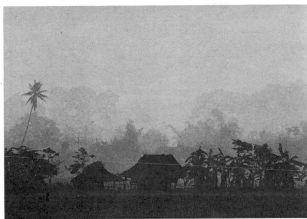

Heat haze in the tropics, particularly when the air is humid, can be sufficiently intense to create distinct planes in the photograph. A long-focus lens tends to enhance this effect.

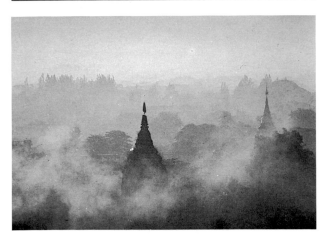

Given hazy or misty conditions, here exaggerated by a pall of wood smoke, shooting towards a low sun makes the atmospheric conditions more obvious and creates silhouettes.

Natural light: Weather

Because bad weather discourages photography, it is all the more interesting for being less obvious. Provided that the camera equipment is well protected, a falling barometer can promise unusual, and even spectacular, pictures. It is the unpredictability of changing weather, rather than reliable 'postcard' lighting, that produces conditions suitable for memorable photography.

Storms Although unpredictable, storms can produce moments of dramatic lighting, particularly when a shaft of sunlight appears through dark clouds. There are no sure ways of anticipating this, although a high viewpoint over a landscape may give some advance warning. The light levels may change rapidly, so monitor the meter reading constantly. The most effective exposure setting is usually the one based on the *brightest* parts of the scene, so that the stormclouds remain dark and threatening in the picture. Be prepared to work quickly.

Rain Falling rain usually appears as pale streaks, and over a distance looks like mist. Sunlight and rain together are not common, but when they do occur, backlighting against a dark background is about the best way of emphasizing the streaks of falling drops. Otherwise, to convey the sense of wetness in a photograph, include some of the *effects* of rain, such as drops hanging from leaves, the spattered surface of a pond, umbrellas, or water sluicing off a roof. There is sometimes a bluish colour cast (correct with an 81A or 81B filter), and colours over all are paler.

Snow Although snow falls more slowly than rain, the slow shutter speeds forced by the poor light still usually cause the flakes to appear as streaks. The effect over a distance tends to be dappled and foggy. A wide-angle lens will slow down the apparent movement, but even so, a shutter speed of about 1/125 sec is needed to show individual flakes. Colours are pale and weak, particularly if there is already snow on the ground. It often helps to include at least a small accent of colour, such as a stop-light in a wintry view of a city street.

Rainbows These occur when sunlight strikes falling rain, and how full and colourful they look depends on the size and quantity of raindrops. Slight underexposure intensifies the colours on film. You can alter the background to a rainbow by moving your position – the rainbow is an optical effect, and so moves as you move. To capture a full arc usually needs a wide-angle lens of around 28 mm or 24 mm.

Lightning During the day, it would take impossibly good luck to time the shutter accurately, but at night, lightning is easy enough to photograph by leaving the shutter open and the camera aimed, on a tripod, in the direction of the last flash. Subsequent flashes then expose themselves. Leave the shutter open for one or several flashes, as you please; the only danger with a long exposure is that if surrounding clouds are moving, their outlines may appear repeated in the picture.

As a general rule, with ISO 64 film, use an aperture of f11 for lightning within about 2 miles (3 kilometres), f5.6 up to 10 miles (16 kilometres), and f4 over 10 miles. For an idea of the distance, count the time between the lightning and thunder: 5 seconds equals about one mile (1.6 kilometres).

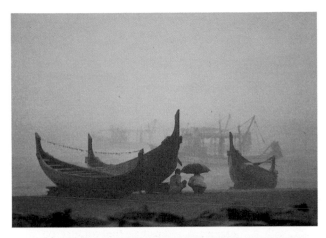

Even though the intensity of a torrential downpour is difficult to convey fully in a still picture it has a special misty, monochromatic appearance through a long-focus lens. The sheltering figures in this view of a South-west Indian monsoon help to show the conditions.

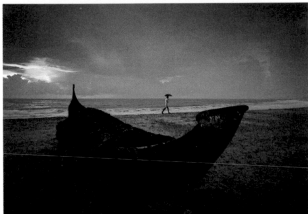

Stormlight – a break of sunlight in the middle of stormclouds – is as interesting an addition to a landscape as it is unpredictable. Rapid shooting is usually necessary.

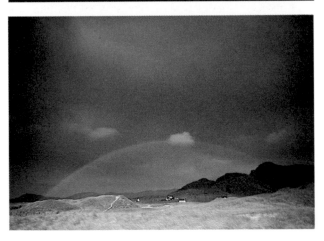

Another bad weather condition that is unpredictable and short-lived is a rainbow. It depends on a combination of sunlight and rain, and a wide-angle lens is usually necessary, as here, for a full view.

Natural light: Dusk and night

Just as bad weather can be used to bring visual relief from run-of-the-mill daytime lighting, so night can give a fresh look to landscapes, even if the dim light does tax regular films. Long exposures are inevitable, but the only two technical considerations of any importance are supporting the camera firmly and measuring the exposure time accurately. As a tripod is likely to be needed even with fast film, its hand-holding advantage in available light situations (see pages 20-3) is lost, and the finer grain of regular film makes it the better choice for most moonlit and twilit landscapes.

Twilight For an hour or two before sunrise and after sunset (the length of time depends on how steeply the sun rises and sets, and if there are clouds) the only illumination is light reflected from the sky and clouds. The special feature of twilight in a clear sky is that it grades gently from the relatively bright horizon to darkness above – exactly the sort of effect that many studio photographers go to great lengths to achieve by aiming lights from the base of a white wall or a large diffusing sheet. It gives a good, simple background for silhouettes, and also smooth, interesting reflections in water and shiny surfaces (and for this reason it is widely used for photographing cars on location). Apart from local differences, twilight before dawn is essentially the same thing as twilight in the evening.

Because the light level is low, long exposures are normal. If the view is too dark for the meter, measure it by (temporarily) turning the camera's film speed dial up, and then allowing for the difference. For example, using ISO 64 film, the meter display may not register, but if you turn the dial up to ISO 250 this will show a reading of f2.8 at one second – from this, use a setting of f2.8 at *4* seconds. Check the information on pages 170-1 to see if the film which you are using needs allowance for colour shift.

Moonlight This is, in fact, reflected sunlight, although roughly 400,000 times weaker. So, a scene lit by a full, clear moon will appear in some ways as it would on a sunny day, provided that the exposure is long enough, by about 19 stops. In addition, even more exposure is needed to allow for reciprocity failure (see pages 170-1), and it is wise to bracket exposures very widely. As a rough guide, when the moon is very bright, expose ISO 400 film for about 3 minutes at f2.8, and ISO 64 film for 20 minutes or more. Consider, however, slightly shorter exposures to give a darker 'night-time' feeling. If the picture includes the sky, stars are likely to appear as streaks.

To photograph the moon itself, use about 1/125 sec at f8 on ISO 64 film if the moon is very bright. If the moon is hazy, or not full, increase the exposure by 2 or more stops.

Photographed by the light of a full moon in a clear sky, the exposure here, on Kodachrome 64 film, was 30 min at f3.5. Reciprocity failure was corrected with a CC 20 red filter.

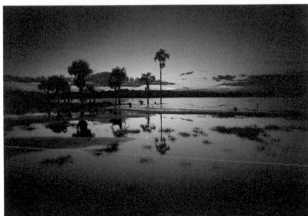

To retain the feeling of twilight, it is often better to expose for a fairly dark image rather than for average tones. Objectively, this evening landscape was under-exposed by about one and a half stops.

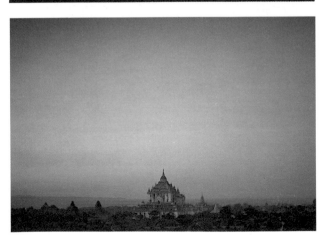

The sky at twilight is often interesting enough to dominate the composition, particularly if there are any distinctive skyline shapes, such as this temple, to provide a base to the picture.

Special locations

At extremes of latitude, and at high altitudes, the conditions of natural light change, and in the tropics, polar regions, or high mountains, it is easy to misjudge some of the lighting qualities. In addition, if the surroundings themselves are very bright, they too have an effect.

Tropical light Close to the equator the sun rises and sets at the same times whatever the season. At noon, the sun is overhead, or nearly so, and its light is not particularly attractive for most subjects. Flat landscapes appear flatly lit, while subjects with pronounced shapes cast deep shadows underneath and appear contrasty – too much for most films. Heat shimmer blurs distant views, particularly with a long-focus lens, and ultra-violet scattering is high.

The best advice for general photography is to avoid shooting in the middle of the day if at all possible, or at least to avoid scenes that have equal amounts of sun and shade. Early morning and late afternoon are probably the best times for most shots, although they are short, as the sun rises and sets more quickly than in middle latitudes.

For some stark, graphic compositions, the lunar quality of midday light may, however, be an advantage; use the shapes of strong black shadows as a part of the image. Even though midday may feel hotter and look brighter than mid-morning or mid-afternoon, the light level does not change between about 8.30 a.m. and 3.30 p.m. Follow the meter reading to avoid under-exposure: the shortest exposures are not likely to be less than about 1/500 sec at f8 on ISO 64 film.

Polar light In contrast to the tropics, sunlight in the far north and far south is weak, warmly coloured, and highly seasonal. Beyond the Arctic and Antarctic Circles, the sun reaches no higher than 40° even in mid-summer, and in mid-winter does not even rise for at least some of the time. Against this, there is continuous light in the summer, leaving more than enough time for photography, and the quality of light is often attractive. For the problems of snow, see below.

Mountain light In the thinner air of high altitudes, there is more ultra-violet radiation and higher contrast. As a result, distant views have a strong blue cast on film, shadows are intense, and the sky itself is often a rich blue. Avoid the worst effects of ultra-violet light by using a strong (yellowish) UV filter, by not shooting towards the sun, and by taking photographs in the early morning or late afternoon rather than in the middle of the day. The high contrast is unavoidable; expose for sunlit areas rather than shadows, and consider using fill-in flash.

Snow, sand, and water These bright surroundings reflect enough light on to a subject to make a noticeable difference. Snow has the most pronounced effect, but light-coloured sand, large areas of water, and the seashore are similar.

These reflective surroundings increase the over-all brightness of a scene, often by about one stop. They also light up the shadows underneath subjects – very noticeable and usually an advantage in portraits. Always use a lens shade to avoid flare, which is more likely in these conditions.

Metering a subject, such as a person, in bright surroundings poses no special problems, but photographing the surroundings themselves needs careful exposure, especially with snow. First decide how dark or light you want the snow to appear in the photograph; it generally looks best when it appears *just* white – that is, not so washed-out that it loses its texture. A TTL meter reading will only show how to record it as a grey mid-tone (see pages 30-1), so as a rule of thumb, give 2 stops more exposure than a reading of the brightest area. Alternatively, take an incident light reading (see pages 32-3). For safety, bracket exposures.

The texture of snow and sand appears strongest under low, raking sunlight, early and late in the day. By aiming the camera slightly towards the sun, you will find that you can catch the sparkle of small crystals. Shadows on snow and white sand reflect the colours of the sky, and so often appear an intense blue on film.

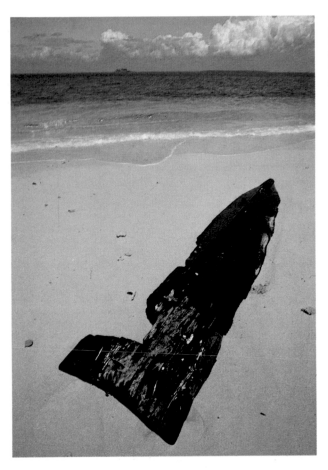

The distinctive shape of a piece of driftwood, made to dominate the composition by shooting close with a wide-angle lens, gives interest to a midday photograph of a tropical beach. Simple compositions are often the most successful with stark, overhead lighting (left).

Photographed at dusk with a long-focus lens, these Andean peaks have a delicate appearance, with little evidence of ultra-violet haze. A UV filter was used as an extra precaution (below left).

Deep blue shadows from the clear sky are here used to good effect by setting them against the warm tones of the barn, lit by a late-afternoon winter sun (below).

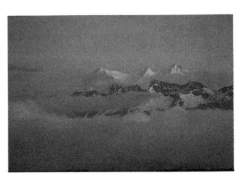

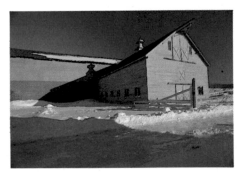

Available light: Outdoors

There are several kinds of artificial light that can be seen in any city at night – street lighting, window displays, floodlighting, and so on. The variety of colours, intensity, and shading can either be an attractive asset to the picture or a nuisance, depending on the type of photography, but what sets apart this available lighting *outdoors* from its equivalent *indoors* is that there is little that can be done to change it. There is, in most situations, no question of replacing lamps, and the scale of outdoor views is too great for flash to make more than a local impression. Nevertheless, filters can make a difference in a few cases, and now that high-speed films and wide-aperture lenses are common, many more kinds of photography are practical.

Each of the three main kinds of available lighting – tungsten, fluorescent, and vapour lamps – has its own characteristic colour, not necessarily the same on film as it may look at the time. On daylight film, tungsten is orange, fluorescent is green, and vapour lamps either yellow or blue-green. In indoor photography, one or the other usually dominates a scene, and corrective filtering becomes a possibility (see pages 22-3). Outdoors, however, lighting is more often mixed, so that no one filter can correct all types. Perhaps more important is whether colour correction is necessary, or even desirable. The combination of different lamps is more likely to enhance a city scene than spoil it. If colours *do* need to be corrected, see pages 22-3.

The main limitations in low-light photography are:
- [] Shutter speeds slow
- [] Exposure readings difficult to make
- [] Focusing difficult
- [] Light sources often in shot, causing high contrast and flare
- [] Artificial light sources make colour balance difficult

Lenses Fast lenses allow higher shutter speeds, although wide maximum apertures, in the region of f1.2 or f1.4, limit depth of field quite severely. For reasons of optical design, the fastest lenses are close to standard focal length, generally between 35 mm and 85 mm.

A few lenses, designed specifically for night-time use at full aperture, have expensively ground aspherical front surfaces, and so give less flare when light sources appear in the picture.

Wide-angle lenses are less prone to this problem of flare than telephotos, and are also easier to hold steady when shooting at a slower shutter speed.

Film High-speed films also allow faster shutter speeds, although the price is a grainier image. However, when a tripod can be used instead of holding the camera by hand, a fine-grained emulsion may be better. Even if one or two things are moving in the picture, as long as the surroundings stay sharp the picture is likely to work. Most films can be given a higher speed rating and extra development (see pages 40-1). With long exposures, some films show less colour shift than others (see pages 170-1).

Supporting the camera A tripod, even a small one to place on top of a wall or a bench, is always useful. Otherwise, practising the hand-holding techniques on pages 68-9 will help improve the slowest shutter speed that you can manage without camera shake. Nevertheless, use any available support, such as a lamp-post. Aim to be able to use a standard lens on a 35 mm camera steadily at 1/15 sec.

Measuring exposure Lighting, particularly in streets at night, is often uneven, and only a spot reading may be useful. The exposure guides on pages 34-5 should be more helpful, but in any case, bracket generously. If the meter is not sensitive enough, set the rating higher as described on pages 16-17. A small penlight may make it easier to read some meters.

Focusing If the scene is too dim to focus on the subject, focus instead on something brighter at the same distance, such as a street-lamp. Otherwise, estimate the distance and rely on the lens scale. Wide-angle lenses need less critical focusing.

Composition Silhouettes against the light need less exposure than other types of image. Side-lighting that picks out just the edge of a subject, such as a face in profile, also allows slightly shorter exposures.

A tripod-mounted time exposure works well for most static subjects and if there is some partial movement, as in this fairground ride, the streaking may be a bonus.

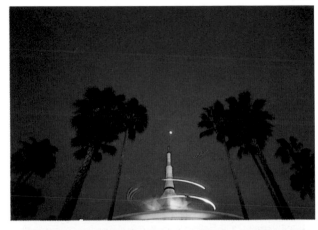

In a long shot of a city, with no single, well-lit subject, the range of acceptable exposures is fairly wide – up to about 2 stops. This shot, at dusk, was taken at 10 sec and f2.8.

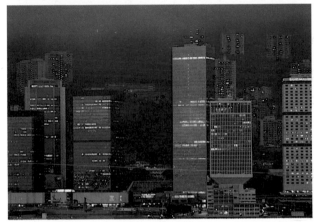

With a fast, wide-angle lens, in this case 24 mm at f2, hand-held exposures are often possible. Shooting at twilight retains some tone in the sky.

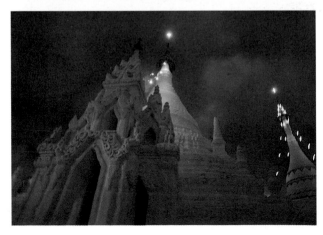

Available light: Indoors

In interiors, particularly small ones such as homes and offices, there is often some chance of being able to balance the lighting to the film, or vice versa. The essential first step is to be able to identify the *dominant* light, not always easy if there is daylight from one window together with strip lamps concealed in the ceiling and tungsten desk lamps, for example. If the lighting is well and truly mixed, it is usually better to favour one type of light, by turning off others or by waiting until evening to reduce the daylight.

Tungsten The colour of tungsten lamps, from yellow to deep orange, depends mainly on the wattage (also the voltage, but this changes little). Domestic lamps appear distinctly orange on daylight film, and slightly orange on Type B film, and have a colour temperature (see pages 164-5) of 2500K to 2900K. To balance:

☐ Use Type B film and an 82C (or similar) filter
☐ Use daylight film and an 80A *and* 82C filter
☐ Replace with a photoflood lamp in the same fitting (no filter with Type B film, 80A with daylight film). Be careful that the photoflood is not too hot for the fitting
☐ Replace with a blue photographic lamp in the same fitting and use daylight film with no filter
☐ If the lamp is out of shot, cover with a blue gel

Fluorescent Widely used in large interiors and offices, fluorescent lamps are coated to give a visual white. However, they nearly all lack red, so that photographs taken without a filter have a green cast. Makes of lamp vary, and judging the exact filter needed is not practical just by examining the lamp.

☐ As a rule of thumb, use a CC30 magenta filter (or a proprietary fluorescent-correction filter, which is nearly the same thing) with daylight film
☐ Much better is to test in sufficient time to use the exact filter. To make the test, see table below.
☐ Replace the lamp with a 'daylight' lamp made especially for photography
☐ Cover the lamp with a magenta gel
☐ Aim a photoflood up into the lamp fitting. This adds some of the missing red

Mercury vapour Because of their intensity, mercury vapour lamps are used for large-scale lighting, such as in a sports stadium. Although visually bluish-white, they are usually deficient in red and yellow. Filtration is difficult to predict.

☐ Bracket the filters as follows, using daylight film: no filter/CC20 red/CC40 red. Even so, perfect correction may not be possible

Sodium vapour These lamps, used mainly for street-lighting and floodlighting large buildings, appear yellowish to the eye and are even more strongly yellow on film. They completely lack blue, and so are impossible to correct entirely with filters. There is little to do but accept the colour cast, or use black-and-white film.

Frame	1	2	3	4	5	6	7	8	9	10	11	12
f-stops:	−½	±	+½	−½	±	−½	±	−½	±	−½	±	+½
filter:		no filter			10 magenta			20 magenta			30 magenta	

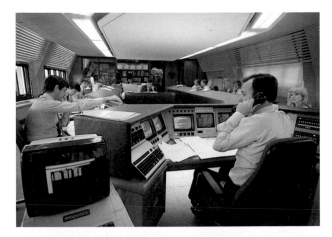

Many office interiors have a mixture of fluorescent, tungsten and daylight. The green cast of fluorescent tubes is the main problem: one solution, used here, is to aim tungsten lamps towards the fluorescent fittings and use daylight film.

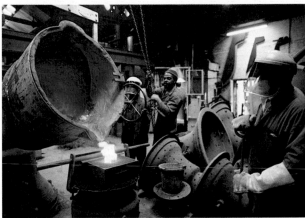

When the principal source is daylight through windows or a skylight, high-speed film and a wide aperture offer the most straightforward method. Light levels are rarely high.

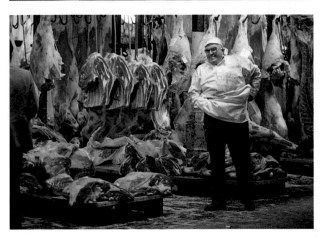

Tungsten lighting does not always demand filtration or tungsten-balanced film. In many situations, the orange cast on daylight film is quite acceptable.

Photographic lighting: Tungsten

Tungsten lighting pre-dates flash in studios, although it is not now as popular. Lamps vary from photofloods, which are essentially an uprated version of regular household bulbs, to powerful quartz-halogen lamps, but all produce the same colour of light – more yellow than daylight, but appearing white on Type B, tungsten-balanced film.

The basic question is whether to equip a studio with tungsten or flash lighting. This depends very much on the kind of subject (see table opposite).

Lamps The simplest and most basic lamp is a photoflood: frosted, usually 500 watts in output, and with a regular screw or bayonet fitting. It can be used in a wide variety of housings. Some makes of lamp are silvered inside to give a more concentrated beam; these are not intended for use in reflectors.

More efficient, intense, and less likely to develop a warm colour cast with age is a tungsten-halogen lamp, available in several shapes and with different fittings. The usual output is 850 watts or 1000 watts.

The colour of photographic tungsten lamps is 3200K (see pages 164-5), balanced for Type B film or for daylight film and an 80B filter. Alternatively, the lamps can be balanced to daylight film by covering them with blue gels (not so close that the heat will damage them) – useful when adding tungsten lamps to daylight. See the checklist on pages 146-7.

Housings and reflectors The quality of the light can be altered with a great variety of fittings. Usually, the lamp holder itself modifies the light, but in addition there are reflectors and diffusers that can be used separately. Fresnel spotlights are heavy, lensed housings that produce a concentrated, adjustable beam. Reflector bowls of various shapes, silvered or white, broaden and soften the light. Fitting a diffuser close to the lamps is not safe because of the heat. See the checklist on pages 146-9.

Tungsten on location Small holders with quartz-halogen lamps make the most convenient location kit, packed with extension leads. Spring clamps can replace stands for

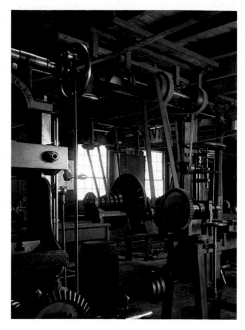

Large interiors, such as this engineering workshop, need so much light that a long exposure with tungsten lamps is usually more practical than flash (above).

In a situation where movement is important, one of the most effective ways of showing it is by streaking in a time exposure. If artificially lit, this needs tungsten lighting, as here, in this picture of a Foucault pendulum (opposite).

portability. To use abroad, take plug adaptors, a screwdriver, and two sets of bulbs: 110/120 volts and 220/240 volts. Whereas flash would need a heavy transformer for use in different voltages, tungsten needs only a change of bulb.

Battery-powered lights are made for video and movie work, and can be used in still photography. However, they are much heavier and less powerful than portable flash, and the batteries also need frequent recharging. See the checklist on pages 146-7.

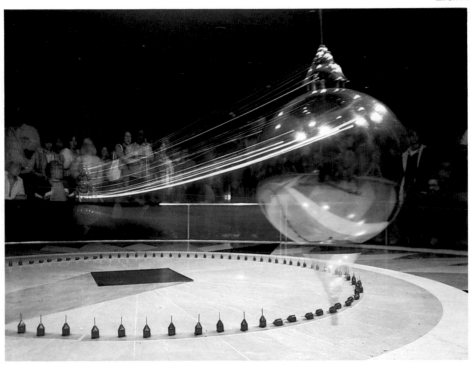

Tungsten versus flash	
Tungsten	*Flash*
☐ Good for a large amount of light with a still subject: for more light, lengthen the exposure. Ideal for large interiors	☐ Can be mixed with daylight, as it is the same colour
☐ Relatively inexpensive	☐ Good for stopping fast action, in acrobatics, for example, or a liquid being poured
☐ Looks exactly as it photographs	
☐ Because the light is continuous, tungsten is essential for streak photography and any other kind of deliberate motion blur	☐ Cool, quick, and comfortable to work with
	☐ Needs a modelling light to pre-view the result
☐ Hot, so not good for anything that will melt or wilt, like ice-cream and fashion models, and dangerous to use with any close-fitting diffusing attachments	☐ Relatively expensive
	☐ Weight-for-light, heavier than tungsten
	☐ Has an upper limit to its light output. Beyond that, the flash has to be tripped a number of times
☐ Not bright enough to freeze very fast movement	
☐ Uncomplicated: the only thing likely to go wrong is a bulb, and this can be replaced immediately	☐ Technically complex; not recommended for DIY repair
☐ Some makes of lamp are extremely small and light, and very convenient for taking on location	

Photographic lighting: Flash

A flash unit discharges a concentrated pulse of light the same colour as sunlight, and in many ways it is more useful for still photography than tungsten. The uniformity of lighting from most portable units tends to give flash a bad name – unjustifiably, as it is the most adaptable of all light sources. Used unvaryingly on the camera, it certainly can give a dull, unimaginative quality to photographs, but used with the range of reflectors and diffusers which are shown on pages 146-9 it is capable of almost any effect.

Most flash is now electronic, although flash bulbs have a few special uses, and it can be powered either by mains or battery. Portable flash units are dealt with on pages 28-9.

Mains flash In studios, portability is not an issue, and flash units can be larger, more powerful, and run off the mains circuit. Flash tubes are usually in the shape of a ring, but occasionally are spiral or linear for more power. All are designed to be used in a wide variety of fittings that alter the quality of the lighting, and because a flash tube builds up little heat, it can be installed safely in an enclosed window diffuser, which would not be suitable for hotter tungsten lamps.

A capacitor stores the charge and releases it in a short pulse. Some units combine everything in one housing, others have separate, smaller flash heads running off one power pack. Free-standing power packs can usually be linked in series, for more power.

Generally, the more powerful the flash, the longer it lasts, and the 1/1000 sec typical of a large flash used at full power will not freeze fast movement as well as a small portable flash, which can deliver a pulse as short as 1/50,000 sec in some cases.

Guide numbers, which are a simple indicator for portable flash, have little use in the studio, where the light may be passed through all kinds of diffusing material. Instead, studio flash is measured in joules – the electrical load from the capacitor to the flash tube. Most single-head units are between 400 and 1000 joules, but weaker and more powerful units are available.

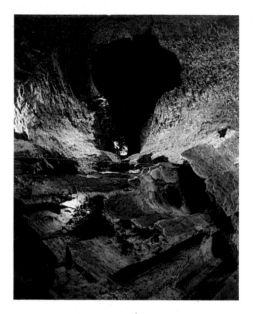

Judge the power necessary according to the smallest apertures you are likely to use with your normal film; the larger the film format, the smaller the minimum aperture: f22 or f32 is typical for 35 mm, but f45 or f64 for sheet film. For example, a 1000-joule flash diffused through opal perspex will allow apertures of around f22 or f32 for most still-life shots on ISO 64 film. A flash meter is an essential accessory unless the camera has TTL flash metering (see pages 142-3).

Special-purpose flash Ring flash heads surround the lens for virtually shadowless lighting. Stroboscopic units produce a rapid succession of flashes for multiple exposures of a moving subject.

Flash bulbs Some simple cameras, like the Polaroid SX-70, use flash bulbs, which need the minimum of electronics and are expendable. Large professional bulbs have occasional uses, particularly in lighting large areas and where there is no electrical supply. Guide numbers in the region of ISO 220 (feet)/67 (metres) are typical for these large bulbs. Flash bulbs are coloured blue to match daylight film.

In large spaces with no mains electricity, flash bulbs can be used. In this cave, two bulbs were triggered simultaneously (left).

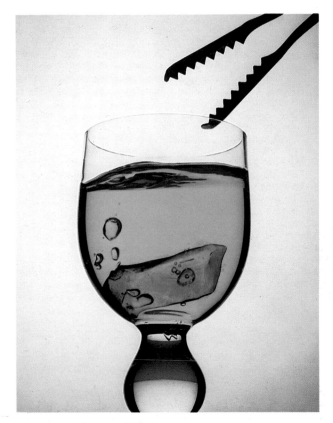

In the studio, a mains-powered flash unit can provide sufficient light for minimum apertures even when the lamp is diffused, and can stop most action, such as movement of liquids (right).

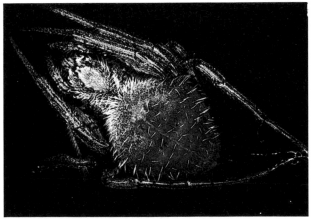

A ring flash provides shadowless illumination, a suitable technique for the complete texture of this tropical spider (left).

Photographic lighting: Portable flash

Although portable electronic flash units offer a very limited quality of light, they are small and convenient, and useful either when the available lighting is unsatisfactory, or to fill in dark shadows, particularly in back-lit shots. The potential drawback with portable flash is that, when used on the camera and without imagination, it tends to give a dull uniformity to photographs. However, by varying its position and by diffusing it, flash lighting can be given variety.

Most portable flash units are automatic, in that once they have been set for the film speed, and the lens set to a certain aperture, they adjust the exposure whatever the distance to the subject. Newer, dedicated flash units, which are linked automatically to the camera's shutter and viewfinder display, allow TTL flash readings; these are accurate even when several flash units are used together, or when close-up extensions are fitted to the camera.

Just as automatic cameras give average exposures of average subjects, so automatic flash units give predictable results as long as neither the image nor the conditions are unusual. Non-automatic units, however, or automatic units that have been switched to manual for full power, need some calculations.

Calculating exposure This is unnecessary with an automatic unit although, as with ordinary exposure measurement, if you want the result to be lighter or darker than average, adjust the aperture accordingly (see pages 30-1). With manual units, use either a flash meter or divide the guide number by the distance to the subject for the aperture setting. Some guide numbers are quoted in metres, others in feet; be careful not to confuse the two. Always allow a few seconds after the unit's 'ready' light appears, otherwise it may not deliver a full charge.

Synchronization Between-the-lens shutters can be used at any speed, but the more common focal plane shutters have a maximum speed for flash, usually around 1/60-1/100 sec. This is usually marked in red on the camera's shutter speed dial. With many dedicated flash units and electronic cameras, the speed is set automatically.

A hot-shoe coupling on the camera connects the flash to the shutter, but the separate sync terminal, marked 'X', allows an extension lead to be used for placing the flash off-camera. When fitting two or more units together, use a sync junction or, better because it removes the danger of overloading the circuit, a photo-cell slave.

Flash position On the camera is convenient and easy, but this tends to give flat lighting, under-lit backgrounds and 'red-eye' in portraits (reflections from the retina). Alternatives are:

☐ Hold or fix the flash to one side, using an extension lead

☐ Aim it at a white ceiling or wall to spread the light. The sensor on an automatic flash will compensate for the light loss; if non-automatic, open the aperture by 2 or 3 f-stops

☐ Sync the main flash with a second or third, placed to one side to fill in shadows or behind the subject for effects lighting

☐ If the subject is static and the surroundings dark, place the camera on a tripod, open the shutter, and fire the flash by hand from several different positions

Fill-in flash When the sun is bright and in front of the camera, important detail may be lost in shadow, particularly with portraits. To lighten these shadows, use a flash on the camera at less than its normal power. A satisfactory ratio of flash to daylight is generally between 1:2 and 1:4. Calculate the exposure on the daylight reading, make sure that the shutter speed is no faster than the sync setting, and then cover the flash tube (but not the sensor) with a neutral density filter (see page 48) or white handkerchief. For a ratio of 1:2 use an ND 0.30 or single thickness of handkerchief; for 1:4 use an ND 0.60 or fold the handkerchief once.

By definition, fill-in flash changes the nature of the shot slightly rather than transforming it. In the upper photograph, no flash was used, and the exposure calculated to produce a silhouette. In the lower picture, a 1/4-power flash gives more visual information. Both are effective.

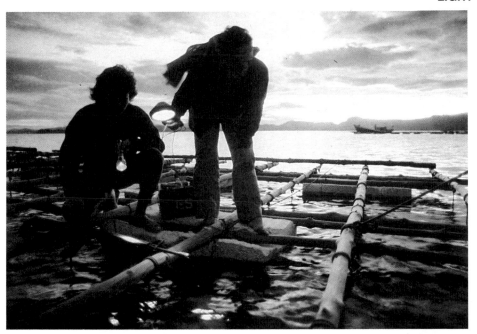

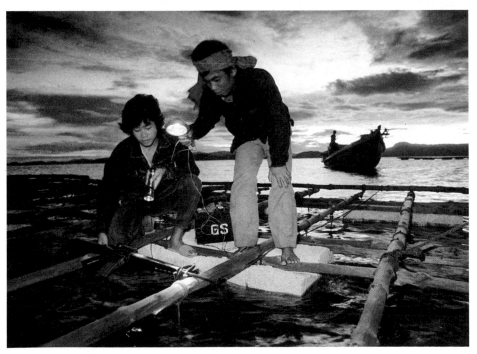

Exposure measurement

In a normally exposed photograph, the image appears about as bright as the real scene does to the eye. In many situations, this is as much as most photographers want, and so exposure meters are designed to give just this information – how to produce an image of *average* tones. This is the baseline for practically all exposure calculations: a mid-tone, halfway between pure white and dense black. To some extent, this is a technical requirement, because film can only record detail if it receives a fairly consistent amount of light, but it also reflects what most people consider to be normal.

However, techniques based on average situations and average demands tend to produce average results. The danger of automated exposure is that it discourages camera-users from even thinking about brightness, tones, and contrast. Some of the most interesting images have a distinctly non-average appearance: strongly backlit scenes, for instance, or the focus of interest small and either much lighter or darker than its background. Photographers' tastes also vary, and there is usually some reasonable degree of choice of how dark or light a photograph should be. The correct exposure is the one that gives you the exact tones that *you* want.

Over-all brightness Different ways of taking measurements are shown on page 32, but remember that whatever area of the scene the meter reads, the aperture and shutter speed that it recommends will result in a mid-tone. The most straightforward approach to exposure is to decide how much darker or lighter than this mid-tone you want a particular subject to be, and then change the aperture or shutter speed to suit. For instance, for a white-painted church to appear white in a photograph, you would need to increase the exposure from the average meter reading, by almost 2 f-stops.

If you prefer images that are *consistently* lighter or darker than average, it may be more convenient to set the meter a ½-stop higher or lower; some cameras have provision for this, otherwise just change the ISO rating on the film speed selector.

Contrast The difference in brightness within a scene or photograph is called the contrast range, and can be measured in f-stops. On a dull, overcast day, a typical landscape may have a contrast range of only 5 or 6 stops, but some scenes in bright sunny weather can have a range as high as 9 stops. Most films can handle only moderate contrast (transparencies typically 5 stops, negatives typically 7 stops), so that some detail will be lost somewhere. Exposing to hold the highlights makes shadows appear black in a contrasty scene, while giving more exposure to preserve shadow details makes the highlights appear washed out. Specific examples are shown on pages 36-7.

Safety margins Inaccurate exposure is probably the most common technical worry in photography. Even when you are certain of how you want the final image to look, there is always the possibility of miscalculation or mistake. However, to some extent the film itself can absorb some error, and by making a series of different exposures the risk can be virtually eliminated.

Over-all brightness 1
Irrespective of the meter reading, a dark subject like this interior, if it is to appear realistic, should print darker than average (left).

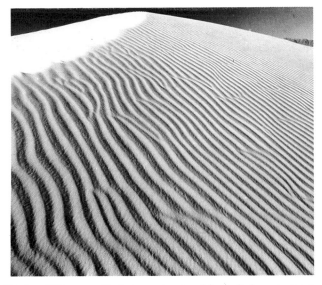

Over-all brightness 2 Similarly, if the subject is basically light in tone, as this sand-dune, the exposure should be more than the meter indicates (right).

Film latitude The exposure latitude of film determines how great a difference in brightness it can record. With a high-contrast scene, it may be fully used up, but with low-contrast subjects it leaves room for exposure mistakes of up to 1 or 2 stops. Negative films have more latitude than transparencies.

Bracketing, or varying the exposure, is a fail-safe technique.

Bracketing The standard technique to insure against mistakes, particularly in tricky lighting conditions, is to make different exposures of the same scene, varying from each other by a ½-stop. Although this is expensive in film, it is not wasteful if the shot is important (if the shot is *not* important, is it worth taking?).

How you measure the exposure for any particular photograph depends partly on the kind of meter you use, but partly also on the appearance of the subject and the lighting. Low-contrast views present fewer problems than those with extremes of light and dark.

For any of the three methods shown below, if you cannot approach the subject to take a reading, use a *substitute*; in other words, take the reading from a surface with a similar tone in the same light. For details of meter operation, see pages 142-3.

Average reading Average scenes, with no great difference between the brightest and darkest parts, are the standard fare of photography:
□ *TTL meter* Follow the reading, or set the camera to automatic
□ *Hand-held meter* Point the meter directly at the subject, shading the top with your hand if the sky is bright; alternatively, take an incident reading at the position of the subject, using the white plastic cover
□ *Spot meter* The special qualities of a spot meter are not really necessary here; take a reading from a mid-tone, or use the high-low method shown below

High–low reading This more sophisticated technique measures the contrast range, and is especially useful for high-contrast subjects. If the range is too high for the film you are using, decide whether you are prepared to sacrifice shadows or highlights (most people prefer to lose shadow detail):
□ *TTL meter* Take two readings, one from the brightest part of the subject, the other from the darkest (if necessary, move in close or fit a long-focus lens to take these measurements). Then, if the contrast range is within the latitude of the film, set the exposure midway between the two. If not, either hold highlight detail by setting the exposure 2½ stops darker than the highlight reading, *or* hold shadow detail by setting the exposure 2½ stops lighter than the shadow reading
□ *Hand-held meter* Take direct readings in the same way as with a TTL meter, or take two incident readings – one in full lighting, the other heavily shaded
□ *Spot meter* This is the ideal meter for this technique; take the readings as just described

Key reading This method forces you to decide the relative importance of different components of a scene. It is particularly useful in situations such as this, where the important subject is small and lit different-ly from the rest of the picture:
□ *TTL meter* Either move close, or fit a long-focus lens, to take a reading from what you consider to be the main focus of interest, ignoring the setting; then, increase or decrease the exposure according to whether you want this to appear lighter or darker than average
□ *Hand-held meter* This is only useful if you can approach the main focus of interest and take a reading from close by
□ *Spot meter* Ideal for this method; take the readings as just described

Average reading

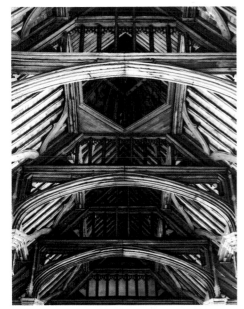

Key reading

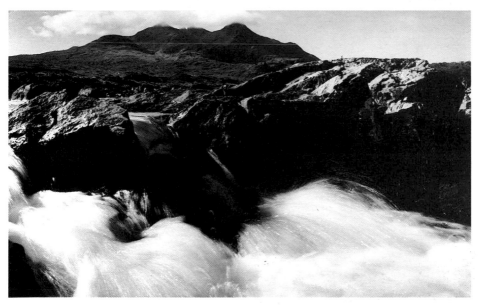

High–low reading

Exposure guide: Night

In night-time pictures out of doors, precise colour rendering usually matters only if flesh-tones appear – at other times, it is atmosphere, not accuracy, that counts. If people dominate the picture, try to balance colour as explained on page 22. Otherwise use daylight film without filtration. Night-lights can mislead your camera's meter, so use the settings shown here as a guide, and bracket exposures where possible.

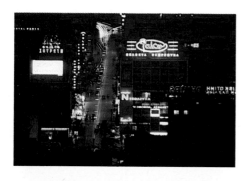

Mixed lighting, with neon displays very prominent, is typical of downtown districts at night and there is unlikely to be one pronounced colour cast. Usually only main streets are lit evenly, and an over-all meter reading of a scene like this is of little value. A time exposure, tripod and cable release are the normal technique, and car lights will appear streaked. Daylight film ASA 64: 20 sec at f32.

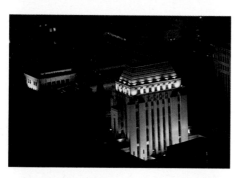

Sodium vapour lamps are common for floodlighting large buildings. Most are aimed at buildings from ground level, so that lighting is often uneven. Filtration has hardly any effect; the result will still be yellow. Daylight film ASA 64: 60 sec at f5.6.

Neon displays are so strongly coloured that no filter is really necessary to compensate for the green fluorescence. Use a shutter speed of 1/30 sec or slower, as neon tubes flicker. Daylight film ASA 64: 1/15 sec at f2.8.

KEY:	TWILIGHT	D	Use the settings given here as
	TUNGSTEN	T	a guide for exposure and
	FLUORESCENT	FL	filtration when it is difficult to
	SODIUM VAPOUR	SV	measure the light, but always,
	MERCURY VAPOUR	MV	where possible, bracket
			exposures.

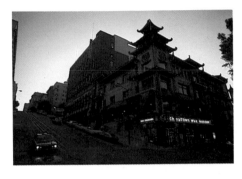

Twilight is useful to define the outline of buildings, but do not base exposures on the sky, or the photograph is likely to be under-exposed. Tungsten display lights do not need filtration, as they illuminate nothing. Daylight film ASA 64: 1/2 sec at f3.5.

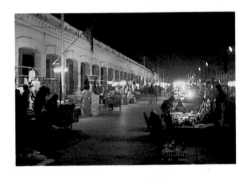

Street market lighting is usually mixed (here fluorescent and tungsten), and lamps appear in shot. Over-all illumination is uneven, but because of this, a wide range of exposures is acceptable. If no single type of light is dominant, use no filter. Daylight film ASA 400: 1/15 sec at f1.4.

Let firework displays make their own exposure by aiming the camera, on a tripod, at the point where they burst, and leaving the shutter open. The aperture setting depends on the intensity of the display; this was a very bright burst. Daylight film ASA 64: about 5 sec at f5.6.

Exposure guide: Daylight

These examples are fairly typical of the range of natural lighting conditions, and those on the next pages represent more unusual lighting. The small diagrams show the contrast range (compare with that of typical transparency and negative films: 5 stops and 7 stops respectively).

Use them to check your meter readings, or as a guide in case of meter failure. Average exposures are given for the most

ASA 64 : 1/250 sec at f8
ASA 125 : 1/250 sec at f11
ASA 400 : 1/500 sec at f14

Bright sun Shadows sharp and deep. Contrast very high, but depends on tone of sunlit subjects. Sky has middle tone. This shot was exposed to hold highlights, so losing shadow detail.

ASA 64 : 1/250 sec at f5.6
ASA 125 : 1/250 sec at f8
ASA 400 : 1/500 sec at f10

Hazy sun Shadows moderate with slightly softened edges. Contrast moderate. Sky bright.

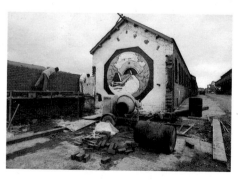

ASA 64 : 1/125 sec at f5.6
ASA 125 : 1/250 sec at f8
ASA 400 : 1/250 sec at f10

Overcast No definite shadows. Contrast low between ground subjects, but ground-to-sky contrast quite high.

commonly used film speeds. For any other film speed, alter the exposure in proportion: for example, ISO 100 film is half as fast again as ISO 64 film ($^{100}/_{64} = 1\frac{1}{2}$), and so needs a ½-stop less light.

For average subjects in sunlight, with the sun behind the camera:

$$\text{Exposure} = \frac{1}{\text{ISO rating}} \text{ sec at f16}$$

ASA 64 : 1/60 sec at f2.8
ASA 125 : 1/60 sec at f2.8
ASA 400 : 1/125 sec at f5

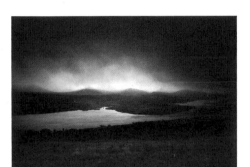

Heavily overcast No shadows. Seems dark to the eye, and parts of sky darker than land. Light level changeable.

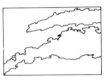

ASA 64 : 1/125 sec at f4
ASA 125 : 1/250 sec at f4
ASA 400 : 1/250 sec at f7

Fog and mist Very low contrast, but light levels very changeable. Appearance of scene often changes quickly. This exposure average between dark and light areas.

ASA 64 : 1/250 sec at f16
ASA 125 : 1/500 sec at f16
ASA 400 : 1/1000 sec at f20

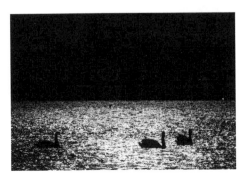

Backlighting Against a bright sun or its reflection, contrast extremely high. This exposure calculated to hold highlights – that is, the reading of highlights plus 2 stops.

37

FILM/Colour films

The differences between individual makes of colour film (listed on pages 166-7) are fairly subtle and largely a matter of personal taste. The choice between the three main types – transparency/negative, daylight/tungsten, and fast/slow – is more fundamental.

Transparency or negative The choice depends essentially on the final use, for although each can be converted to the other, negative film is the best choice for good-quality prints at a reasonable cost, and transparency (reversal) film is the natural starting-point for slides or for images published in magazines and books (reproduction houses are geared for making colour separations from transparencies). The chart below shows the permutations, but note that second-generation images, where one image is converted into another, usually lose some quality.

On the face of it, transparency film appears more flexible, but colour negatives have some special advantages: they have more exposure latitude and so are more tolerant of errors and high-contrast lighting, and colour imbalances can be corrected easily in the printing. Transparency film produces its finished product in one step, and demands greater accuracy.

Daylight or tungsten Most films are daylight-balanced – that is, to the colour of the midday sun and flash – but some are designed for the more orange light of photofloods. For these tungsten lights, and for others in house interiors, Type B films are more convenient, although for occasional shots without changing film, CB filters can be used with daylight film (see pages 48-9 and 166-7).

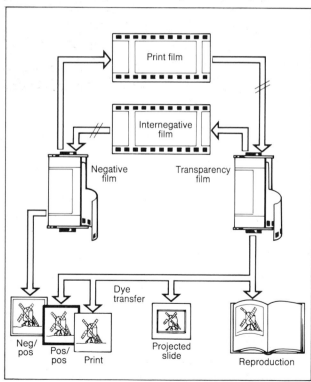

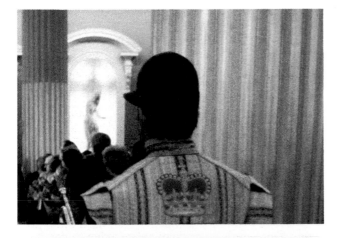

ISO 1000 transparency film shows pronounced grain – the price for being able to shoot by available light indoors.

On ISO 25 Kodachrome, detail holds well in a similar enlargement, without any appearance of graininess.

Fluorescent lamps lack red, and so are better photographed with daylight film (filtered).

One special advantage of tungsten film is that it is designed for long exposures and so suffers less from colour shifts when the shutter is open for several seconds. Because of this, daylit interiors may be easier to photograph using tungsten film filtered with an 85B.

Fast, medium or slow Slow film has fine grain and can reproduce more detail and stand greater enlargement. It does, however, need more light, and for situations where the light level is low or where a fast shutter speed is needed to freeze action, a fast, grainy film is the regular choice. Also,

for some images, the speckled effect of pronounced grain can be an asset. Push-processing (see pages 42-3) increases the speed and the grain.

Special-purpose films False-colour infra-red is the only film made deliberately to alter colours from their real appearance, and contains one layer of dye that is sensitive to invisible infra-red. Apart from its scientific uses (identifying healthy vegetation and other infra-red reflectors), it has unusual pictorial qualities, which can be altered with filters.

Photomicrography film has high contrast and fine grain, and apart from its intended use is worth considering for detailed copyshots.

Black-and-white films

Without the complicating quality of colour, black-and-white films offer a simpler choice. Most use the traditional silver process and vary only between slow, fine-grained emulsions and fast, grainy ones. A radical alternative is the dye-image (chromogenic) process, which uses colour negative film chemistry to produce a silverless image. The differences between silver and dye-image films are:

☐ Dye-image films have a finer structure and so resolve more detail. This also means, however, that they lack the distinct grain texture that many photographers like and that can sometimes *look* sharper

☐ Dye-image films have much more exposure latitude, and so tolerate mistakes and can even be rated from about ISO 100 to 1600 *on the same roll of film*. They can also handle high-contrast images better

Among regular films, the slow makes have *finer* grain and a slightly higher contrast – ideal for highly detailed images, provided that the subject is not moving too fast for the inevitably slow shutter speeds. Fast films are needed for rapid action and for hand-held available light photography; as the grain in Tri-X and HP5 only

Slow, fine-grained film is the normal choice for detailed subjects in which the textural and tonal qualities are important and which do not need a high shutter speed. ISO 32 film was used for this architectural shot.

becomes noticeable in large prints, many professional photographers use these ISO 400 films for general work.

Because processing is basically simpler for black-and-white film than for colour, there are special developers to enhance sharpness and speed. See pages 170-1 for details, but remember that it is the *film* rather than the developer that makes most of the difference. Push-processing (see pages 42-3) is straightforward.

Special-purpose films Infra-red film offers unusually different images, particularly if used with a visually black 87 filter (used without a filter, the result is not so diffe-rent from ordinary film, as the infra-red sensitivity is overpowered by visible light). Vegetation can appear white, a clear sky black, and haze disappears. Grain, however, is strong, and resolution can be a little fuzzy.

Agfa Dia-Direct and Polachrome CT and HC are slide films, but regular films can also be used to produce slides given different processing (see pages 170-1).

Line films produce extremely high-contrast images, and although used mainly in graphic arts, have pictorial uses, such as making strong silhouettes. See pages 168-9 for the range available.

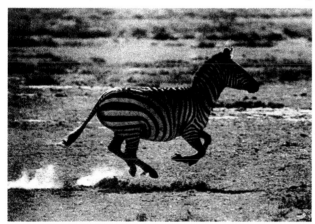

Fast, grainy film has obvious advantages when the subject moves fast. This zebra was photographed at 1/500 sec, panned, on ISO 400 film.

Infra-red black-and-white film is sensitive to the high infra-red reflectivity from green leaves and clouds. If an opaque filter is used to cut out visible wavelengths, the effect is an unusual tonal distribution. An 87 filter was used here.

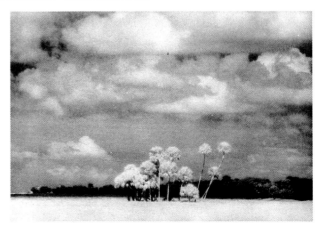

Changing film speed and colour

Although films are intended to be used at their published ISO ratings and developed accordingly, the processing can be altered so that they behave as if they were faster or slower. This is useful when there is not enough light to use the film normally, to correct mistakes that have been discovered before processing, and also to adjust some of the more subtle qualities of the image, such as contrast and grain. Increasing or decreasing the development by a ½-stop can make useful minor adjustments (in still-life photography, for instance, it is common practice to 'push' the film by this amount to clean up the whites), but if the development is altered by more than one full stop, some qualities of the picture, like shadow density, are likely to suffer. Use with discretion.

Most good laboratories will alter development by up to 2 stops (see pages 170-1). If you make an error in exposing the film – say, using an ISO 64 film as if it were ISO 125 – simply instruct the laboratory to alter the development by the same amount (in this example, 'pushing' the film by 1 stop). If you plan in advance to alter development – for instance, to reduce contrast – change the ISO rating on the meter or camera accordingly.

With black-and-white film, altering development is extremely useful for controlling contrast, and has few unpleasant side-effects. With colour film, however, there is usually a slight change in colour, and this can be a nuisance, even though a filter will correct it. Some films suffer altered development worse than others; Kodachrome, for instance, becomes very grainy, and Kodak laboratories will not undertake altered development (a few private laboratories will, but the advantages are marginal).

Reversal as negative A special effects technique is to process colour transparency film as if it were negative (for example, Ektachrome in C-41 process). Not only are all the tones reversed, but the colours as well.

Transparencies from negative film Although Agfa Dia-Direct is specially made to produce black-and-white transparencies, other black-and-white negative films can give similar results with special processing. Kodak Panatomic-X and Ilford Pan F give good results, although highlights remain slightly grey. Rate Panatomic-X at ISO 80, Pan F at ISO 125, and bracket exposures.

How altered development affects the image

Increased ('pushed') development
- □ *Faster film speed* This is the most common reason for push-processing
- □ *More contrast* May be useful in flat lighting to give more 'snap' to the picture
- □ *Weaker blacks* The maximum density (that is, in the shadow areas) becomes thinner
- □ *More grain* Usually a disadvantage, but useful for a deliberately speckled effect, like some Impressionist paintings
- □ *Colour shift* In colour film, the three different layers react differently; the over-all effect varies from film to film, but using Kodak's E-6 process the colour cast tends slightly toward red, by about CC05 if pushed a ½-stop, CC10 if 1 stop

Decreased ('cut') development
- □ *Slower film speed*
- □ *Less contrast* This is a useful technique when the contrast range in the scene is too great for the film
- □ *Colour shift* With colour films, this varies between makes, but E-6 process films tend towards cyan or blue, by about CC05 if cut a ½-stop, CC10 if 1 stop

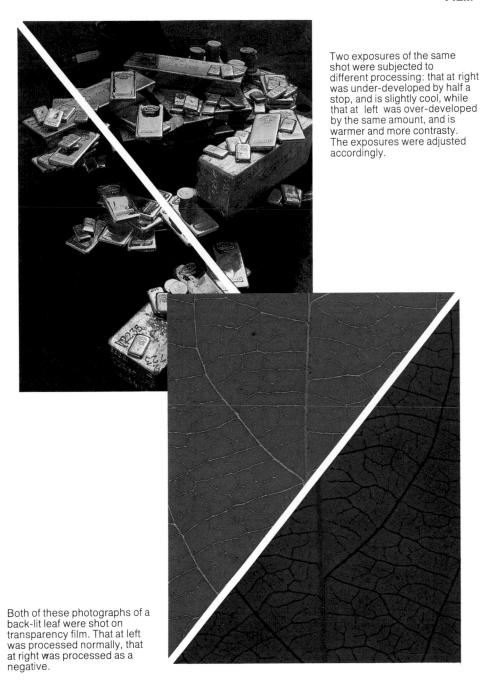

Two exposures of the same shot were subjected to different processing: that at right was under-developed by half a stop, and is slightly cool, while that at left was over-developed by the same amount, and is warmer and more contrasty. The exposures were adjusted accordingly.

Both of these photographs of a back-lit leaf were shot on transparency film. That at left was processed normally, that at right was processed as a negative.

Film faults

Always make an effort to identify the reasons for film faults, otherwise you can never be certain when they may happen again. The next four pages show some of the most common; use them to compare with any that you suffer.

If the cause is not so obvious, try first to identify in what stage of the picture-making process the problem lies. Faults that include the rebate (the film's dark edge, sprocketed on 35 mm) are unlikely to have occurred when the picture was taken; optical faults, which usually show variations in sharpness, normally involve the lens. Use the fault analysis chart below as a guide.

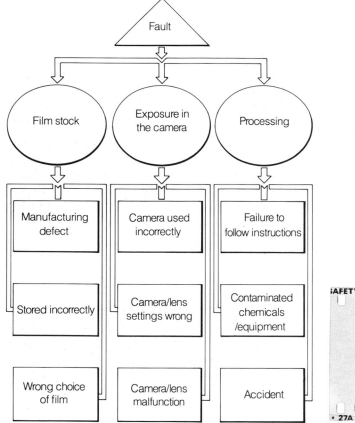

1. EXPOSURE PROBLEMS
Unexposed negative Film has not been exposed, either because of improper loading, or because light did not reach film.

Unexposed transparency
Same as unexposed negative.
Shutter or mirror action may be
at fault, or very high speed used
with flash.

Gross under-exposure Too
extreme to be error of
judgement. Could be wrong film
speed setting, meter fault,
shutter fault or under-
development.

Under-exposure If bright
subject, wrong metering
technique (see page 30). If
average subject, wrong film
speed setting or under-
development likely.

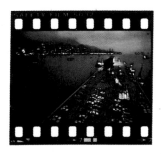

Over-exposure Wrong film
speed, faulty meter, shutter
action sticking, or over-
development.

Gross over-exposure Non-
automatic camera pointed at
very bright light, shutter sticking
open, or aperture failing to close
down.

High contrast Very bright
subject next to dark or average
background. Instead, use fill-in
reflectors and a more diffused
light source.

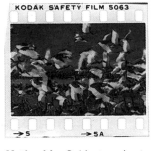

2. SHARPNESS PROBLEMS
Soft focus Fuzziness of detail,
becoming sharper away from or
towards camera. Likely with
telephoto lenses and in poor
viewing conditions (e.g. night).

Camera shake Differs from soft
focus in that sharp details appear
doubled under magnifying glass.
Unsteadiness at slow shutter
speeds.

Motion blur Subject moving too
fast for shutter speed. Not
always a fault: can be attractive,
impressionistic effect.

FILM/FILM FAULTS

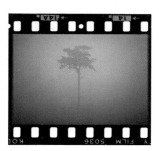

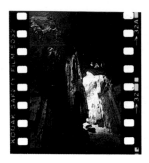

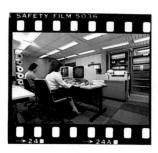

3. COLOUR FAULTS
Green cast If natural lighting, likely to be reciprocity failure (see page 170).

Purple cast Also reciprocity failure, on different film stock.

Green cast If under strip-lighting, normal reaction of film to fluorescent lamps.

Blue If evening or early morning, normal reaction to dusk sky.

Purple sky Reaction of Kodachrome to certain kinds of neutral graduated filter.

Slight cast Batch difference in film, poor storage of film, or wrong filters.

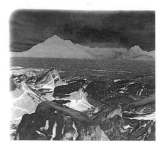

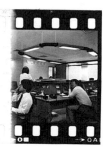

4. INCOMPLETE PICTURE
Corners/Edges dark Wrong lens shade cutting off picture.

Partly blank If white, like this, start or end of film. If black, wrong flash sync.

Overlap Film transport faulty. Sometimes happens with motor drive at start of film.

 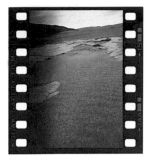

5. UNEVENNESS
Uneven blue sky Polarizing filter used with wide-angle lens.

Darkened edge Graduated filter left on lens by mistake.

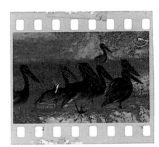 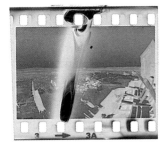

6. MARKS
Scratches and clip marks
Usually clumsy handling in processing.

Drying marks Film stuck together on reel during processing.

Crimp mark Rough handling when loading film for processing.

 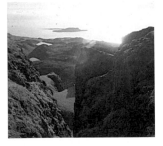

Light leak Camera opened before film wound back, or bright light on cassette.

Flare Shot too close to sun, inefficient lens shade.

Flare Internal patterns of lens diaphragm. See left.

Filters: Colour film

Even small differences in colour are very noticeable in a transparency or print, and filters are important for fine control over the image. Filters can be used either to correct the colours and tones to those which you consider normal, or for creative effect.

Colour balancing filters These adjust colour temperature as it appears on film (see pages 164-5). The Kodak series includes yellowish filters to lower colour temperature (81 weakly, 85 strongly) and bluish filters to raise it (82 weakly, 80 strongly). The two most common uses of colour balancing (CB) filters are to make domestic lamps appear less orange and to warm up outdoor scenes under overcast skies.

Colour compensating filters In six basic colours and six strengths, colour compensating (CC) filters allow any correction to colour shift caused by batch difference, reciprocity failure, altered development or artificial light source. In situations where you can judge the colour shift on a test transparency, choose a filter for the remainder of the shooting as follows:
1. Overlay filters of the colour opposite to the shift on the transparency on a light box until you find the one(s) that look *visually* correct.
2. Use a filter of *half* that strength for shooting. For instance, if a blue cast appears corrected by a CC20 yellow filter, use a CC10 yellow.

Neutral density filters These simply reduce the exposure, and are different shades of grey. Use them when the shutter speed or aperture cannot be reduced sufficiently (such as in bright light or with fast film), or to alter exposures with flash units and cameras that have separate automatic sensors (see pages 28-9 and 64-5).

Ultra-violet filters These filters, usually colourless but sometimes a pale yellow, for extra strength, absorb invisible ultra-violet (UV) radiation that exaggerates haze on film and gives a blue cast to distant views. They are particularly useful for long-focus lenses and in mountains and the tropics. UV filters also protect the front element of the lens from dirt and scratches, and for this reason many photographers fit them permanently.

Polarizing filters These filters, which reduce exposure by 1⅓ stops (a TTL meter automatically compensates for this), can be used to reduce reflections and to darken blue skies. They work with light that is already 'polarized' such as sunlight, or artificial light shone through a sheet of polarizing material. Rotate the filter for greater or lesser effect; check this visually through the viewfinder or by pointing the mark on the rim of the filter towards the light. Outdoors, the polarizing effect is strongest at right angles to the sun, and in this direction is very good at cutting through haze. A warning, though: with a wide-angle lens, so much sky is in shot that it appears patchily darkened.
☐ Reduce reflections from water and other shiny, non-metallic surfaces
☐ Darken blue sky
☐ Reduce haze

Graduated filters Partly toned, partly clear filters with a transition zone in the middle gentle enough not to be noticeable in the photograph (unless used with a wide-angle lens at a small aperture). They are especially useful for darkening cloudy skies with transparency film or dealing with uneven lighting. Two together, one upside-down, give a thin strip of light in the middle, useful for simulating stormlight or night when centred on the horizon in a landscape shot. Neutral graduated filters have more general uses than coloured.

Selective filtration Cut a gelatin filter so that it covers just part of the image. This is a DIY alternative to graduated filters and can be tailored to fit areas of unusual shape. To avoid an abrupt edge in the photograph, use a wide aperture.

A straight, unfiltered photograph of this rock-face shows little more than the reflection of sunlight (opposite above). Using a polarizing filter, however, removes the shine from the surface and reveals a pattern of rock carvings (opposite below).

A neutral graduated filter can be used to enrich the colours of a sky (above right). Had the exposure simply been reduced instead, the foreground would have been too dark (right).

Single-colour filters can be used either to enhance a particular atmosphere, or for simple graphic effect (above).

A fog filter gives a soft, muted effect to landscapes, and is useful for producing pastel colour (left).

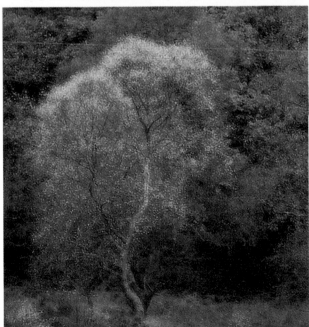

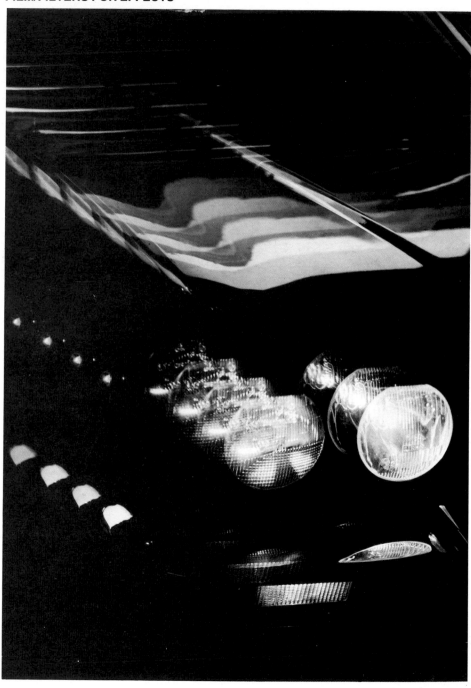

Various kinds of prism filter, having different facets, give multiple images. Rotating the filter determines the direction of the repeated images (left).

With highlights, a soft-focus filter gives a mild halo effect, particularly against a dark background (right).

In this special effects photograph, a star filter was used to create rays of light from a small lamp (above).

Diffusers The surface of these filters is etched or mottled to reduce sharpness and contrast. They can make skin appear smoother in portraits and produce a halo in back-lighting. They can also, however, create a cliché of romanticism.

Fog filters These simulate the effect of fog or mist by reducing contrast and colour saturation, and even give an impression of depth if they are graduated so that the lower half is clearer. Breathing on the lens has a similar effect.

Star filters Crossed etching gives a star effect to points of light.

Prism filters These create multiple images, in a pattern determined by the number of cut facets and their arrangement.

Diffraction filters These superimpose rainbow-coloured streaks in various patterns.

Coloured filters These simply give a strong colour cast.

Colour polarizing filters The colour can be changed by rotating these filters.

Split-diopter lenses See pages 110-11.

Anamorphic lenses Designed for Cinemascope motion picture cameras, these lenses stretch the image in one direction. Use with a small aperture to keep the image sharp.

Fish-eye attachments These give a poor-quality fish-eye effect to a regular lens.

Filters: Black-and-white film

All of the filters described for colour film, except those that rely for their effect on changing colour, work equally well with black-and-white film. However, for darkening blue skies in black-and-white an orange or red filter is more efficient than a polarizing or graduated filter. Remember also that many effects are easier to create when printing, under the enlarger.

A special, and very valuable, type of filter control is possible by using coloured filters. The numbers given in the chart are from the Kodak Wratten series, although other manufacturers have similar ranges.

Contrast control In black-and-white photography, colours are reproduced as tones only. As film is more sensitive to blue light and less sensitive to red light than are our eyes, blues tend to appear too light and reds too dark in photographs. To correct this anomaly, or to separate similar tones (red and green, for example, often appear a similar grey), or to emphasize certain parts of the image, use the coloured filters listed below. Basically, a filter of the *same* colour as the subject lightens it, while a filter of the *opposite* colour (such as red to green, blue to yellow, or violet to orange) darkens it. However, many *natural* colours, such as the green of vegetation, are not very pure, and so do not respond strongly to these filters.

Wratten	Effect
8	Darkens blue sky moderately, lightens vegetation a little. Reduces haze.
11	Lightens vegetation moderately, gives fair skin a natural appearance.
12	'Minus blue'. Darkens blue sky quite strongly. Reduces haze.
16	Similar to Wratten 12, but stronger. Reduces reddish skin blemishes.
21	Darkens blue sky strongly. Lightens brickwork, darkens vegetation. Increases contrast in outdoor views.

Wratten	Effect
25	Darkens blue sky very strongly indeed, darkens shadows, heightens contrast. Under-exposure gives effect of moonlight.
29	Similar to Wratten 25, but even stronger (for example, even darkens pale blue sky near horizon).
32	'Minus green'. Darkens green.
44	'Minus red'. Darkens red.
47	Enhances haze, increasing sense of distance and depth. Lightens blues, darkens yellows.
58	Lightens green vegetation. Darkens reds.

A typical colour transparency film, here Kodachrome 64, reproduces definite hues with considerable accuracy. Black-and-white film, however, if unfiltered tends to produce blues that are paler than normal and reds that are darker.

A Wratten 58 green filter with black-and-white film gives a fairly light sky (similar to the effect without a filter) and noticeably dark reds (the roof at upper left).

A Wratten 25 red filter lightens reds (the roof), strongly darkens the sky, and also gives dark shadows. For its effect on skies – here it even shows up wispy clouds – this filter is popular for producing definite landscapes.

A 47 blue filter removes virtually all tone from the sky, and darkens its opposite colours, including yellow. For both these effects in this picture, it gives the least natural result.

Instant film

Virtually all of the great variety of instant fims are made by Polaroid, and nearly all are for use either in special cameras or in film backs and holders that can be attached to some regular cameras. Polachrome 35 mm slide film, however, can be used just like regular 35 mm film in normal cameras. Instant films can be used:

☐ *For testing* To assess composition, exposure and filtration, many professional photographers, particularly in studios and with large-format cameras, test on Polaroid before committing regular film

☐ *As a finished product* The image quality of many instant films is extremely high, and certainly good enough for gallery display and reproduction. The contact printing process in peel-apart films gives very good tonal gradation. Instant films do, however, have fairly high contrast

☐ *For one-shot events* If the subject moves fast and unpredictably, instant film lets the photographer know whether or not the image has been captured.

☐ *For goodwill* Giving an instant print to a stranger whom you want to photograph often breaks the ice

Colour films

Polaroid Time Zero SX-70 ISO 100 Integral film (that is, there are no parts to throw away) for use in SX-70 cameras. Very stable dyes and an interesting diffuse silver haze. To vary exposure beyond the two f-stop range of the camera's darken/lighten control, use an appropriate ND filter to cover the lens (for darkening the image) or the sensor (for lightening).

Polaroid 600 High Speed ISO 640 Integral film for use in Polaroid's 600 series cameras. Essentially similar to Time Zero but better for poor lighting, such as indoors.

Polacolor ISO 80 Available in several different sizes: 8 × 10 in, 4 × 5 in, 3¼ × 4¼ in, and 3¼ × 3⅜ in. Very high-quality peel-apart colour prints. For richer colours and deeper blacks, increase development time from the standard 60 sec to 75 sec or 90 sec, but use a yellow or red filter of about CC10 strength to correct the blue-green colour shift. The exact filtration varies between batches.

Kodak Instant Color Film EI 150 Integral film for use in Kodak instant cameras with an image size of 2¾ × 3½ in. The surface has a satinluxe finish, rather than glossy.

Kodamatic Trimprint EI 320 Integral film for use in Kodamatic instant cameras with an image of 2¾ × 3½ in. Its special feature is that, within an hour of shooting, a thin, flexible print carrying the image can be peeled away from the backing and then cut or mounted on any flat or curved surface.

Polachrome CS 35 mm ISO 40. Self-processing colour transparency film in 12-exposure and 36-exposure cassettes. Used just like regular film in any 35 mm camera. On-the-spot processing in a special developing kit in three minutes.

Black-and-white films

Polapan Fine Grain ISO 400 positive print film, available in 4 × 5 in sheets. Good separation of tones, high resolution, and a 6½-stop contrast range (moderately high). High print quality. For most work, this is the regular black-and-white instant film.

Type 55

Type 51

Type 52

Type 57

Negative

Polapan

Polaroid High Speed ISO 3000 positive print film. For very dim light or for small apertures and high shutter speeds in normal available light. Available in 4 × 5 in sheets. Grainy, and has high contrast range of only 5 stops.

Polaroid High Contrast ISO 320 in daylight, ISO 125 in tungsten. Positive print film. Available in 4 × 5 in sheets. Extremely high contrast and especially sensitive to blue, which appears white in prints (red appears black). Useful for graphic effects.

Polaroid Positive/Negative ISO 50 for prints, ISO 25 for negatives (4 × 5 in sheets); ISO 75 for prints, ISO 35 for negatives (3¼ × 4¼ in packs). High resolution, good tone separation, and the bonus of a high-quality negative that can be used for enlargement. A well-exposed print yields a thin negative, so that if the negative is the end-product, the print should appear one f-stop too light. Clear and store negatives in sodium sulfite solution until they can be dried.

Polapan CT 35mm. ISO 125. Fine grain black-and-white transparency film. Available in 36-exposure cassettes. Part of the Polachrome range (see above).

Polachrome

Polagraph

Polagraph HC 35mm. ISO 400. High-contrast black-and-white transparency film. Available in 12-exposure cassettes. Part of the Polachrome range (see above). **Contrast control** Except for Positive/Negative film, altering the development time of Polaroid print films affects the contrast by making shadow areas darker or lighter (changing the development time by 50 per cent gives a difference of approximately one stop). With all Polaroid black-and-white print films, delaying the application of the protective coating by a few minutes *lightens* the highlights.

☐ Longer development darkens shadows
☐ Delayed coating makes highlights whiter
☐ Shorter development lightens shadows
You may have to adjust the initial exposure accordingly.

Print care
☐ Never touch the surface of a print
☐ Coat black-and-white prints within three minutes, using the applicator packed with the film; this halts bleaching of highlights and protects against scratches (use six to eight overlapping strokes)
☐ Dry coated prints separately, store in the transparent bag packed with the film

Type 779

Type 778

Type 59

CAMERAS/Types of camera

There are now so many camera models available, with special advantages claimed for each, that the choice appears immense. In reality, there are only a few important types of camera, and the choice between makes is largely a matter of detail and personal preference.

The basic difference is format, with convenience and speed of use in favour of the smaller sizes, image quality and control the main advantage of larger films. Overlaying this basic breakdown is the way that the camera market has progressed, with most of the technological and cost-saving work being put into the most popular camera type – the 35 mm SLR; the result is that this one camera performs well in practically all areas of photography.

Disc and cartridge cameras These are simple, inexpensive, and designed single-mindedly for casual snapshots taken by people who are interested less in photography than in being able to capture an agreeable moment with no fuss. They are intended to produce wallet-sized prints, and this is about the limit of useful enlargement from these films.

35 mm A few rangefinder models have the advantages of being small and quiet (and so useful as a pocket camera or for unobtrusive shooting), but the majority are single lens reflex (SLR). They vary in complexity between makes, but most have interchangeable lenses and through-the-lens (TTL) metering. The 35 mm camera has the widest range of uses of any type of camera, thanks partly to the development of many high-resolution films that overcome the disadvantage of small format, and partly to the enormous range of accessories and special equipment now available.

Above all, the 35 mm is a general-purpose camera, with special advantages in active situations and where fast reaction is needed when shooting. Candid street photography, press, sports, wildlife, travel, and underwater are all areas where 35 mm is ideal. Also, the small film size is an advantage in magnified images with macro and telephoto lenses, as the magnification is greater with any particular focal length.

Rollfilm Apart from a few of the more old-fashioned twin lens reflex (TLR) design, most rollfilm cameras are SLR, and take 120, 220, and sometimes 70 mm film. Frame sizes vary, but the two most common are 6 × 6 cm and 6 × 7 cm. Rollfilm cameras are more bulky than 35 mm and slower to use, but still fairly portable, and they do have the advantage of about four times the picture area. So they are most useful in situations where fine detail and image quality are needed without sacrificing the basic convenience of a camera which is easy to handle. In a way, rollfilm cameras are a compromise between 35 mm and sheet film cameras, but they are ideally suited to some special areas, particularly portraits, architecture, detailed landscapes, and active studio subjects such as fashion and cooking.

Sheet film Large-format cameras, accepting sheet film in sizes from 3¼ × 4¼ in up to 12 × 15 in (a few specialist models take

For rapid hand-held shooting, 35 mm is the ideal format; it is also adaptable for most other uses (left).

For less urgent, more controlled photography, 6 cm rollfilm offers a larger format than 35 mm (above).

For studio use, sheet film in a view camera offers the highest image quality (right).

even larger sizes), are very slow to use, heavy, cumbersome, and need a great deal of light for their small-aperture lenses, but have the supreme advantage of impeccable image quality. Not only can they give intensely detailed images, but camera movements, which control image shape and sharpness, are a standard feature. Technical cameras have some measure of portability, but most are for tripod use, either light, flat-bed field cameras for outdoors, or the much heavier but more precise monorail cameras for studios. The most common formats are 4 × 5 in and 8 × 10 in. Sheet film cameras are ideal for a considered approach, with subjects that can be set up and planned, such as still-life and architecture. They are also invaluable for strong-perspective shots, using tilts and swings, such as in close-up and landscape photography.

In addition, any format can be used in a less familiar role, to produce an unusual treatment of a subject. For instance, street portraits with a large-format view camera are hardly convenient, but the result can be eye-catching in its unexpected image quality and the rather old-fashioned formality of pose and expression that it encourages in subjects.

Instant film cameras Although instant film is now available that fits regular 35 mm cameras, most instant films, producing prints, necessitate the use of either a special holder or a separate camera. The major manufacturer, Polaroid, produces a range of cameras for the different film formats.

Special-purpose cameras There are a number of cameras which are designed to perform one specialized function that is usually beyond the range of regular equipment. These special-purpose cameras include amphibious, 3-D, panoramic, aerial, high-speed, sub-miniature, and multiple-image models.

61

Depth of field

Depth of field is the front-to-back sharpness in a picture; when it is shallow, foregrounds and backgrounds can be completely blurred and out of focus. It is a quality special to photography, as our eyes adjust focus too quickly to notice the out-of-focus areas of a view, and can be controlled in the camera by the aperture.

The details and definitions of depth of field are given on pages 156-7. More basic, however, is the question of how much depth of field is *right* for a particular image, and there is nearly always a choice. A small aperture gives greater depth of field, as does a short focal length, so the greatest depth of field is possible by using a very wide-angle lens stopped down, while the shallowest is given by a long telephoto used at its maximum aperture.

While on the face of it a completely sharp picture may seem to be ideal, this misses the creative opportunity – focusing on only a part of the image draws attention to it. The out-of-focus areas can add an abstract frame, or may be intriguing by not being too obvious.

Great depth of field By convention (and this does *not* mean an unbreakable rule), front-to-back sharpness is useful in the following situations:
☐ Most wide-angle views
☐ Sweeping landscape views
☐ Still-life
☐ Architecture, inside and out
☐ All copyshots and technical records

Shallow depth of field Just as complete sharpness tends to be used in certain kinds of image, so a mixture of sharpness and blur has several good uses:
☐ Isolating any subject from cluttered surroundings, for example, a candid shot of a face in a crowd
☐ Giving a sense of depth to a scene
☐ Obscuring unimportant or unwanted details
☐ Creating an abstract wash of colour or tone
☐ Making patterns and shapes out of bright lights and reflections
☐ Virtually removing foreground obstructions, such as branches in a wildlife shot

The inherently great depth of field of a wide-angle lens (in the example above opposite, 20 mm) is useful for fully expanded views that draw together foreground and background. In the lower photograph, the shallow depth of field of a long-focus lens is used to frame the subjects with an out-of-focus area to underline the candid nature of the shot.

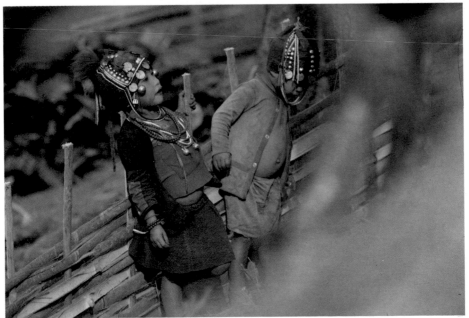

Movement

Just as the aperture setting gives a photographer choice in deciding the depth of field in a photograph, so the shutter speed can be altered to record a moving subject in different ways: sharp, nearly sharp, or deliberately blurred. Sharply frozen movement, using a high shutter speed, is the normal approach, but it often lacks the *impression* of speed and action.

Freezing movement The shutter speed needed for a sharp photograph depends on how fast the image seems to move *through the viewfinder*. In other words, if a running figure is small in the frame, or is moving towards the camera rather than across the field of view, a slower shutter speed will do. The table below gives minimum shutter speeds. When the movement is close to the camera, flash may be better than a high shutter speed: a small electronic flash may discharge in as short a time as 1/50,000 sec (at low power).

Panning Following a moving subject by turning the camera can keep its image almost stationary, particularly if it moves smoothly, like a car, rather than jerkily, like a runner. By contrast, the background is blurred into horizontal streaks, adding to the sensation of speed. The more steadily you hold the camera, the slower the shutter

speed you can use; turn your whole upper body from the waist rather than move only your arms.

If the subject is moving slightly towards the camera, you will have to re-focus as you aim. Trying to keep it sharply focused the whole time can be difficult, and it may be better to focus once, shoot immediately, then re-focus quickly, and so on. Alternatively, focus slightly ahead of the subject and shoot as soon as it becomes sharp; if there is a reference point on its route, such as a mark on a road, this is easier.

Both the lighting and background may change as you pan, and affect the exposure. If the background remains a similar tone to the subject, automatic exposure helps, but if not, as with a bird or aircraft in flight, judge the exposure only on the subject (see pages 32-3).

Streaking If the subject is familiar enough to be recognizable with only a little detail, a very slow shutter speed, such as ¼ sec or longer, may give the best *impression* of movement. The blurred streaks show the action (for example, of a bird's wingbeats). This technique is most effective when the scene has strong contrast or sharply different colours.

Freezing movement: minimum shutter speeds		
Subject virtually filling frame	Camera steady	Panned
Person walking	1/250 sec	1/125 sec
Person jogging	1/500 sec	1/250 sec
Person running	1/1000 sec	1/250 sec (some limb blur)
Cyclist, quite fast (20 mph)	1/2000 sec	1/250 sec (legs slightly blurred)
Galloping horse	1/4000 sec	1/500 sec
Car, moderate speed (40 mph)	1/4000 sec	1/125 sec
Racing car (80 mph+)	Too fast	1/250 sec

Note: A subject that fills only half the frame, or is moving diagonally towards the camera, needs a shutter speed only half as fast as these.

In this head-on shot of a gliding stork, relative movement was sufficiently small to allow a shutter speed of 1/250 sec, but pre-focusing ahead of the bird was necessary for a sharp image (opposite above).

The muscular tension and near-horizontal position of this Indian fisherman hauling a net convey a sense of action, but it is the spray of sand that shows the speed involved (opposite below). The shot was taken at 1/500 sec.

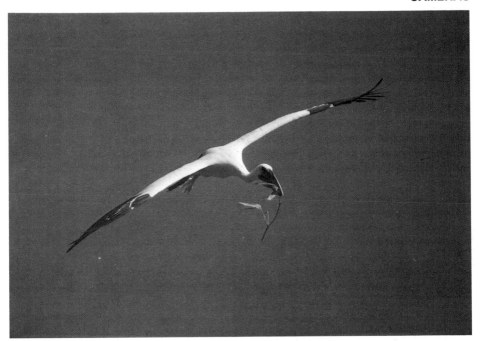

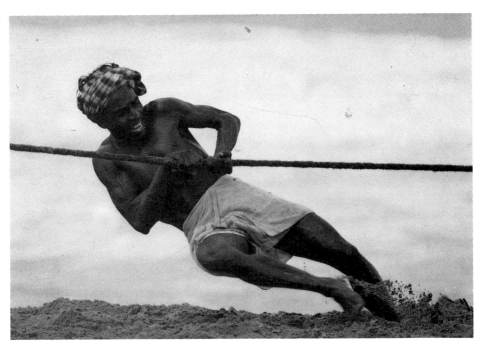

Lenses

The technical descriptions of focal length, maximum aperture, focusing range, and so on mask the really important quality of a lens in use, that it puts a certain character on the image. For example, a wide-angle lens can, if used close, involve the viewer in the action because of its perspective; by contrast, a telephoto view can seem cooler and more dispassionate. In another way, different focal lengths place different stamps on composition – the active, diagonal lines typical of many wide-angle views are characteristic.

Special-interest subjects obviously influence the choice of lenses. A moderate telephoto is invaluable for candid photography, and a long telephoto essential for most wildlife subjects. Also important, however, is the personality and graphic taste of the photographer – some people simply like working at a distance from their subjects and so favour long-focus lenses, and feelings about perspective and distortion can be intensely subjective.

Zoom lenses combine a range of focal lengths, and allow very precise framing. Two or three zoom lenses are essentially an alternative to a larger number of fixed focal length, regular lenses.

Special-purpose lenses Some areas of photography are outside the useful range of normal lens design, and for these there are special lenses available, for instance in close-up, architectural, or low-light photography. Although obviously ideal for one type of use, they are limited in other areas, and so generally are worth owning only if they are likely to be used frequently. For occasional use, an alternative is to hire from a dealer.

	35 mm	Rollfilm	4 × 5 in	Special qualities
Fish-eye	circular	—	—	☐ Circular image, very strong distortion ☐ Graphically extreme, often overwhelming subject
	16 mm full-frame	30–37 mm full-frame	—	☐ Strong barrel distortion ☐ Coverage wider than human vision ☐ Depth of field so wide that lens rarely needs focusing
Extreme wide-angle	13–24 mm	38–40 mm	60–75 mm	☐ Very wide coverage ☐ Shapes stretched near edges and corners ☐ Involving: pulls viewer into picture ☐ Wide depth of field
Medium wide-angle	28–35 mm	50–65 mm	90–120 mm	☐ Wide coverage ☐ Fairly involving ☐ Quite good depth of field ☐ Can substitute for standard lens
Standard	50–55 mm	80–120 mm	150–200 mm	☐ Perspective as human eye ☐ Exerts no graphic influence on image
Medium telephoto	85–200 mm	180–360 mm	240–600 mm	☐ Magnifies ☐ Slight foreshortening ☐ Shallow depth of field
Long telephoto	300 mm up	500 mm up	1000 mm up	☐ Magnifies small area of view ☐ Compresses perspective ☐ Objective, distanced ☐ Very shallow depth of field

The characteristic compression of a telephoto (here 600 mm) gives a repeating pattern of uniforms with virtually no change in size.

A full-frame fish-eye (16 mm) is at the other extreme of the range of lenses. Its coverage along the longer side of the frame is 137.°

Typical uses
☐ Horizon-to-horizon pictures ☐ Scientific recording ☐ In the studio, turning flat subjects into spheres
☐ Confined spaces ☐ Landscapes: exaggerating foreground; very open view ☐ Deliberate introduction of curved lines
☐ Interiors ☐ Involved street photography ☐ Sweeping landscapes ☐ Deep landscape views ☐ Exaggerating foreground ☐ Crowded architectural views ☐ Adding graphic interest to a dull subject
☐ General-purpose lens ☐ Street photography ☐ Architecture
☐ General-purpose lens ☐ Keeping true proportions of any subject
☐ Candid photography ☐ Portraits ☐ Slightly compressed landscapes ☐ Details in general scenes
☐ Close views of distant objects, such as wildlife ☐ Isolating subject from surroundings ☐ Out-of-focus blur effects

Camera handling

A camera is as much a tool as any craftsman's instrument, and as simple a matter as being able to handle it well can make the difference between a picture and a missed opportunity. Most photography is to do with capturing images from fluid situations – circumstances that are never quite predictable, such as the shifting patterns of people in a street scene, the changing expression on someone's face, or even the movement of light and clouds over a landscape.

Identifying the right moment to shoot is part of the art of photography, but translating this on to a piece of film involves something more basic – complete familiarity with the camera's controls, and dexterity. Ideally, camera and lenses should

Camera shake can easily spoil even the best pictures, but if you choose a good, stable posture, you should have little trouble holding the camera level and steady. When standing up to take pictures, try to cradle the camera so that its weight is braced by your body, rather than relying on muscular tension alone to provide a support. Usually you can do this by taking most of the weight of the camera on one hand, and pressing the elbow of that arm into your chest, as shown in the diagrams at right and below.

Horizontal pictures Cradle camera and focus with left hand.

With motor drive Take most of weight on right hand.

Vertical format Again, left hand bears most of load.

Alternative grip May be easier to take weight in right hand.

Verticals with a motor Take extra weight with a similar stance.

constitute a natural extension of the photographer's eye, instruments that can be worked smoothly and easily without having to think consciously.

Even in its controls, a modern camera is complex, offering a choice of settings that can actually get in the way of taking pictures. In a situation that demands full concentration and good reflexes, any time which is spent in fiddling with the mechanics of the camera is obviously going to be a waste. It is much better to practise first, so that adjusting the controls comes completely naturally and automatically and can be done without the need even to look at them. Carrying and using a camera frequently is the best, and most straightforward, answer.

High kneel Use both your arm and leg to support the camera.

Sitting down Works well if you can lean on something.

Long lenses Keep centre of gravity over forward foot.

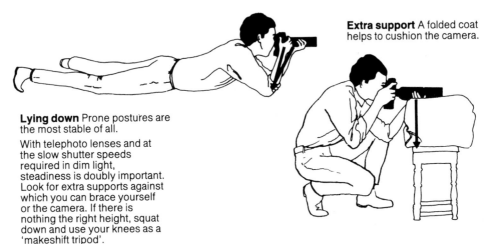

Extra support A folded coat helps to cushion the camera.

Lying down Prone postures are the most stable of all.

With telephoto lenses and at the slow shutter speeds required in dim light, steadiness is doubly important. Look for extra supports against which you can brace yourself or the camera. If there is nothing the right height, squat down and use your knees as a 'makeshift tripod'.

Camera care

Equipment deteriorates with use, but regular care keeps this to a minimum, and most cameras should last years if used sensibly. Check cameras and lenses as shown here, and clean them after outdoor use as shown on the following pages. In addition, give a thorough check to any equipment that suffers damage.

The basic precautions are:
- [] Protect lenses and bodies with caps, and use clear UV filters
- [] Pack equipment securely, as on pages 126-7
- [] Move working parts, such as the cocking lever, gently, without straining
- [] Leave tensioned parts, such as the shutter and FAD (fully automatic diaphragm) uncocked when not in use
- [] Have equipment serviced professionally after every two or three years of normal use, or after each year of constant use

Impact If equipment is dropped or knocked severely, do the following:
- [] Find the point of impact: this is likely to be the front of the lens or corner of the body
- [] Check visible damage, then gently shake and listen for rattling, loosened parts; see if the body is twisted
- [] Operate all moving parts to see if they still function, including shutter cocking and release, film wind-on, speed selector, aperture ring, and focusing; open the back of the camera, aim towards the light and watch the shutter at different speeds to check for sticking
- [] Shoot off a test roll

Sand and dirt Pack equipment in a sealed bag when not in use. If wind whips up sand or dust, wrap camera in a plastic bag as shown. Use a clear UV filter. Clean often. If the camera is dropped into sand:
- [] Blow air into all crevices
- [] Focus the lens as far forward as it will go and inspect for particles; a grating sound will identify any still under the ring – if so, prise out with a thin card
- [] Break down the camera as far as normal; wipe and blow clean
- [] Try all the controls and listen for grating sounds; if they persist, stop using the camera, have it cleaned professionally

Shutter release should not stick

Check that mirror remains unscratched

Check that film speed setting has not moved

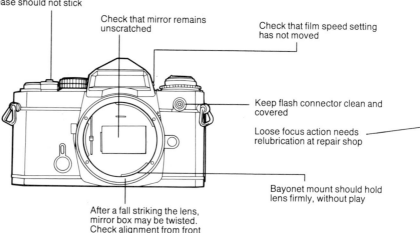

Keep flash connector clean and covered

Loose focus action needs relubrication at repair shop

Bayonet mount should hold lens firmly, without play

After a fall striking the lens, mirror box may be twisted. Check alignment from front

Water Rain or an inadvertent ducking can cause internal corrosion and temporary short electrical circuits. Salt water is much more damaging than fresh. Protect as for dust and dirt (above). After a thorough wetting:
- ☐ Dismantle all parts that can be removed easily
- ☐ Wipe down
- ☐ Dry in sunlight, on a radiator, with a hair-dryer (switched to 'warm', not 'hot'), or in an oven at low temperature
- ☐ Have the camera checked professionally later

If, however, the camera is dropped in salt water:
- ☐ Soak thoroughly in fresh water
- ☐ Dry as above. Better still, take it, still flooded with fresh water, to a repair shop

Heat On hot days, keep cameras in shade, well ventilated, and avoid leaving in enclosed spaces such as locked cars. Most cameras are black and heat up quickly in strong sunlight, and although modern equipment is fairly immune to extremes of temperature, the film inside is not. LCD displays will also suffer damage. Condensation is a bigger problem; see 'Cold'.

Cold Low temperatures shorten battery life (take spares or use an external battery pack kept in a warm pocket) and can make metal stick to skin (cover with tape). More important, moving in and out of cold causes condensation (treat as 'Water' above). Avoid condensation in the first place by keeping the camera cold the whole time or, at least, warming very slowly. If a camera has to be brought into the warm quickly, wrap it first in a sealed plastic bag so that the condensation will form on the *outside* of the wrapping, not the inside. Always protect a warm camera from snow and your breath; both will form water droplets and then re-freeze.

Most cameras will continue to operate at low temperatures, but for safety before a trip to a cold location, put camera and film in a freezer overnight set to the expected temperatures. If it works well the next day, all well and good, otherwise have it 'winterized' by the manufacturer.

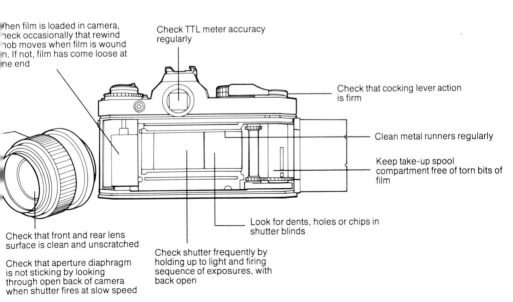

When film is loaded in camera, check occasionally that rewind knob moves when film is wound on. If not, film has come loose at the end

Check TTL meter accuracy regularly

Check that cocking lever action is firm

Clean metal runners regularly

Keep take-up spool compartment free of torn bits of film

Look for dents, holes or chips in shutter blinds

Check that front and rear lens surface is clean and unscratched

Check that aperture diaphragm is not sticking by looking through open back of camera when shutter fires at slow speed

Check shutter frequently by holding up to light and firing sequence of exposures, with back open

Camera cleaning

Clean equipment regularly, and always after shooting on location, when some dirt is inevitable. Dismantle components for cleaning only in a dust-free atmosphere, to avoid introducing more dirt than you remove. Wipe delicate surfaces only when abrasive particles, such as grit and sand, have been blown or brushed away, otherwise they will cause scratches.

Cleaning materials On location, take at least a blower brush and a soft lint-free cloth (such as a well-washed handkerchief). At home, keep a full set like this (right) for thorough cleaning. Never use oil.

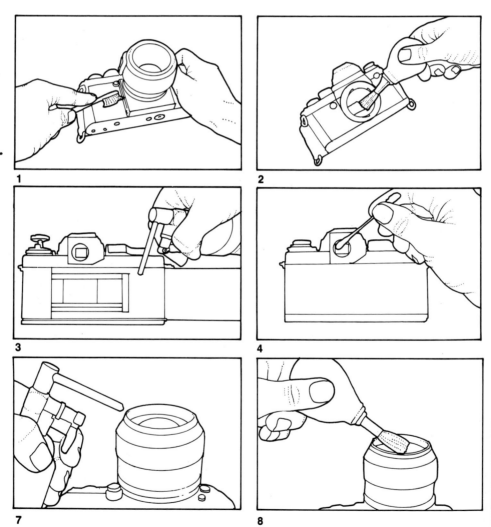

1

2

3

4

7

8

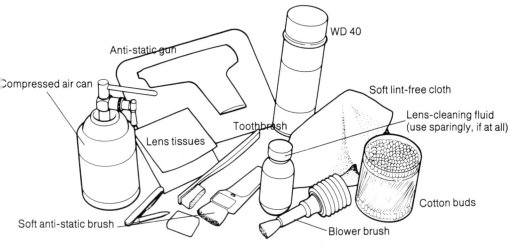

WD 40

Anti-static gun

Compressed air can

Soft lint-free cloth

Lens-cleaning fluid
(use sparingly, if at all)

Toothbrush

Lens tissues

Cotton buds

Soft anti-static brush

Blower brush

1. Remove dirt from crevices on exterior with toothbrush
2. Loosen dirt in delicate areas with soft brush
3. Blow away loosened dirt (but don't use compressed air directly on shutter fabric)
4. Wipe crevices with moistened cotton bud
5. Wipe all parts with soft, dry lint-free cloth
6. Use anti-static gun or brush on interior surfaces
7. Remove filter and blow away particles from lens surfaces
8. Use blower brush on crevices
9. Wipe lens with clean, soft cloth in gentle, circular motion
10. Use anti-static gun and replace cleaned UV filter

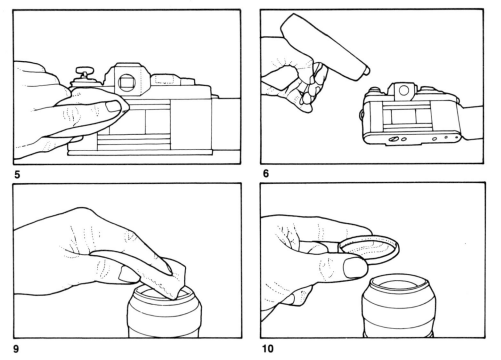

5

6

9

10

Camera repair

Generally speaking, DIY camera repair courts disaster, the more so as in modern designs mechanics are being replaced by electronics. A professional repair shop is the best place for any major camera surgery.

Nevertheless, breakdowns and accidents often happen at the most inconvenient times, and if there is no professional repairer within reach, you may be faced with a straight choice between trying some first-aid and not taking any more pictures. Just be aware of the consequences – a mistake during DIY repair may do more damage than the camera has suffered already.

The very best solution to a breakdown is to have a spare. An extra camera body allows you to pack away the faulty one and go on shooting. A set of interchangeable lenses is, in any case, normal, and having one out of action only restricts your choice.

Identify the fault The problem may be perfectly obvious, especially after an accident. See pages 70-1 for the symptoms to expect from the five main kinds of damage: impact, sand, water, heat, and cold.

Many camera faults, however, have no immediately apparent cause – something just stops working. In this case, the trick is to narrow down the possibilities by first isolating which camera *function* contains the fault. Broadly speaking, these are:

Shutter mechanism
Lens and aperture
Viewfinding
Winding mechanism
Metering
Mirror box

The chart opposite shows the most likely symptoms in each of these parts of a camera. For a non-expert, one of the most useful aids is a second, identical camera in perfect working condition. Side-by-side comparison with the one that is faulty can highlight what is wrong.

However, first eliminate the two 'faults' that are by far the most common: failure to follow the instruction booklet, and battery failure (which, surprisingly, does happen to most people).

Repair procedure Whatever the repair, follow a plan:

☐ Remove unnecessary attachments
☐ Work slowly, in steps
☐ Make a careful note of each step, possibly making a sketch or taking a Polaroid so that you can re-trace what you have done
☐ Keep components such as screws separately by step. Store in small boxes (empty film cans are useful) or on a roll of sticky tape
☐ When bending anything into place, use minimum force. Pad pliers
☐ If a screw has come loose, suspect the part it retained to have moved
☐ Once removed, it may not be possible to replace parts held under tension, such as spring clips
☐ Epoxy is marvellously effective for repairing broken parts quickly, but having it removed later during professional repair may cost you more money

Shutter mechanism	Winding mechanism	Lens and aperture
Mirror box	Viewfinding	Metering

(Instructions in parentheses = temporary first-aid)

Winding mechanism

Jams Check if film has come to end (*change*), shutter has failed to fire (see 'Shutter mechanism'), motor-drive or auto winder is faulty (*remove and work manually*), film cassette is dented and jams (*change*), re-wind button is sticking in re-wind position (*clean and move in and out several times*). Work sprocket wheels by hand in case of sticking.

Film stays still (Re-wind knob should move as film transport lever is wound on). Check if film came loose from take-up spool (*re-load*), is torn (*open in dark, and change*). Work re-wind lever in case of sticking.

Shutter mechanism

Jams Check if shutter lock is on (*unlock*), batteries dead (*replace*), winder not fully cocked (*wind lever to full extent*), mirror jammed (see 'Mirror box'), *fad* linkage to lens damaged (*bend carefully to shape*). If none of these, use mechanical back-up shutter on electronic camera, if possible.

Gives wrong speed Check range of speeds visually by opening back and looking through while firing speeds in sequence. Slow speeds easiest to judge, so start with one second, and check that each successive speed appears to be twice as fast (note: opening back on some electronic cameras limits top speed to the manual fail-safe speed: about 1/90 sec). In electronic cameras, fault may be poor connection due to dirt or moisture (*clean*). In mechanical cameras, higher speeds tend to drift with time (*use slower speeds*).

Lens and aperture

Chipped or broken glass Obvious on inspection. If small, may not spoil image if lens used at a wide aperture.

Loose element Look from both ends for obvious misalignment and anything loose. Shake very gently and listen for rattling. Work focus fully each way while looking through viewfinder: a jerking image at either end of the focus travel needs repair but will not affect pictures. In modern lenses, elements are usually held in place by screws rather than cement; these can be tightened, but access is difficult.

Fungus Looks like patches of staining and is likely in hot, humid conditions. (*Clean with soap and damp cloth*). Any that will not wipe off must be treated professionally. Use lens at wide aperture to reduce blurring.

Aperture stuck Check if aperture ring is jammed (*ease gently*), or if *fad* linkage to mirror and shutter is bent out of shape (*bend gently back*).

Will not focus on infinity Check if an extension ring is still fitted after close-up photography (*remove*), or if elements loose (*see above*).

Metering

No display Check if switched off (*switch on*), batteries failed (*clean or replace*), display designed not to function on first few frames (*wind on*), poor connection through dirt or moisture (*clean or dry*). If none of these, use a separate meter or the film's boxed instructions.

Wrong exposures Check against another meter. Check if film speed set wrongly (*re-set*), if meter has been damaged by being aimed at the sun (*wait several minutes*), if inaccuracy is consistent in all lighting conditions (*if so, adjust speed setting*).

Viewfinding

Image blurred Check if mirror, focusing screen, or prism have come unseated (*put back*), if mirror is not coming to rest at its proper stop (*work gently by hand; if any part twisted, bend gently back*), if condensation or grease on any of the glass surfaces (*clean or dry*). Check that the problem is in viewfinding rather than in the mirror box or lens by focusing on fixed point, then opening back and shutter and placing tracing paper flat against film guide rails (image should be sharp).

Mirror box

Twisted If camera is dropped, the mirror box may be bent. This affects focus and the mirror/shutter operation. Check visually. No simple treatment if bent.

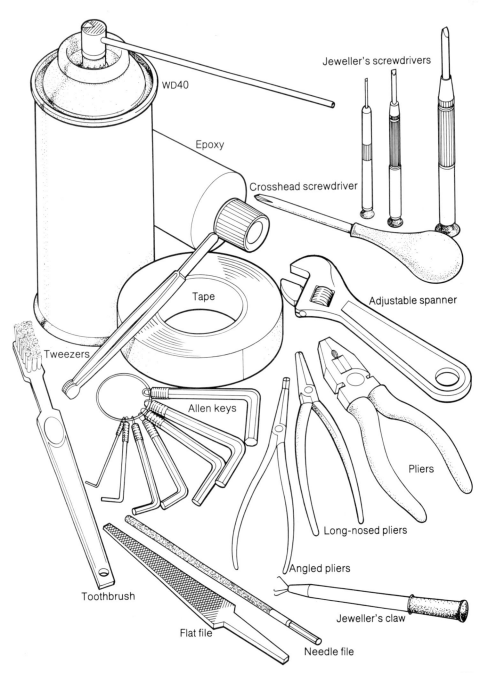

WD40

Epoxy

Jeweller's screwdrivers

Crosshead screwdriver

Adjustable spanner

Tape

Tweezers

Allen keys

Pliers

Long-nosed pliers

Angled pliers

Jeweller's claw

Toothbrush

Flat file

Needle file

Studios

A studio is simply a controlled space for planned photography. It can be a full, permanent conversion, a temporary adaptation, a second use of a living-room, or even a portable structure to take on location. The basic requirements are:

☐ Floor plan large enough for the type of subject and focal length of lens. Camera angle determines the working distance for any given size of subject and background – allow 40° horizontal for a standard lens.

☐ Controllable existing light. A tungsten-lit studio must be fairly light-proof. With flash, this is convenient for judging lighting set-ups, but not absolutely essential as average daylight in most rooms is not strong enough to affect the flash exposure. Shutters, dark blinds, and black paint are typical methods, but in a temporarily converted room, existing curtains may be enough.

☐ Space and power for lights. Overhead lighting adds at least a few feet to the height above the subjects. To save space, paint the ceiling white and aim lamps upwards, so that *it* becomes the light source. Most domestic circuits will carry normal lights, but several 1000-watt tungsten lamps may cause overload.

☐ Lighting flexibility. A selection of diffusers and reflectors gives variety of lighting. Painting the studio white gives maximum shadow fill (good for soft, well-diffused images); painting it black stops it from influencing precise lighting set-ups (good for still-lifes). Coloured walls or ceiling are likely to cause colour casts in shadow areas.

☐ Storage space for props and equipment.

☐ Preparation space: make-up table for beauty shots, dressing-room for fashion, workbench for still-lifes.

☐ Strong, smooth, solid floor. A concrete base is ideal; if wooden, nail down securely. Parquet or tiles make a good surface. In a converted living-room, roll up carpets or, if they are fitted and cannot be moved, place a wooden board under the tipod to keep it steady.

☐ Ventilation and temperature control. Light-proofing can make a studio stuffy. Fit an extractor, or air-conditioning.

Designing a studio space

1. Measure dimensions of largest subjects that are likely to be photographed, and mark in plan on scaled graph paper.

2. For the longest lens likely to be used, sketch the camera angle with a protractor (use the table on pages 162-3) for the angles to the longest side of the picture frame, not the diagonal).

3. Add behind the subject the distance to the background, allowing for effects and background lights, and the distance behind the background for supports. Add at least 3 feet (a metre) behind the camera.

4. Decide how to fit this basic shooting area into the space available (whether permanent or temporary). A simple card model of the room may help.
5. In a temporary studio, see what furniture can be moved with the least disturbance.
6. Check the light-proofing needed. Unlike in a darkroom, it will not normally need to be complete.
7. Note the layout of power points. Extensions and multiple socket adaptors may be needed. Check the load that the circuit will carry.
8. Check if ventilation or heating will be needed.

Studio on location Setting up a temporary studio elsewhere means maximum improvization while keeping fittings to a minimum. Checking existing facilities saves time and effort. A location studio kit might be put together like this:

☐ Aluminium sectioned poles for background and lighting support, assembled with collar clamps; the more interchangeable the support system, the more flexible it is
☐ Background material that can be packed small: cloth or canvas for portraits, paper roll in a hard tube, flexible plastic sheeting that can be rolled
☐ For power offtake from a mains supply: extension cables, spare fuses, a range of plugs, insulating tape, multiple socket adaptors, wire-stripping pliers and voltage-checking screwdriver; always unwind drum cables fully to avoid inductance heating from a heavy electrical load
☐ For power where there is no mains supply use a small petrol generator; a 3-kilowatt model will power 5000 joules of studio flash or three quartz-halogen tungsten lamps
☐ Lamps: small folding holders such as Lowell Totalite for tungsten-lit shots, regular studio flash otherwise; it may be possible to hire lights near the location, or at least the lighting stands
☐ Diffusers and reflectors: white cloth, corrugated translucent plastic (fold with the corrugation), umbrellas
☐ For modifying daylight: scrim to diffuse sunlight, white polystyrene sheets or space blanket to provide shadow fill

SUBJECTS/Natural landscapes

Good landscape photography conveys a personal impression of a natural scene, and not just a documentary record. There are so many components in any landscape – trees, rocks, landforms, lighting quality, weather, and so on – that a casual snapshot may easily look jumbled and unstructured. Most successful photographs refine these elements into a coherent image.

Whatever the style or treatment, and there are as many as there are photographers, landscapes can be approached in three general ways:

☐ *Straight*, giving a clear and recognizable view, often stressing detail

☐ *Impressionistic*, sacrificing some realism and clarity for less obvious qualities such as atmosphere

☐ *Abstract*, using features of the landscape for graphic compositions of shape, tone, or colour

The most important creative controls are lighting, composition, and the choice of lens focal length. Each helps to determine the character of the image.

Lighting Total familiarity with natural light (see pages 8-17) helps to make the best use of existing conditions and, to some extent, to anticipate how a scene will look at a different time of day or in different weather. Although every type of light has its uses, a low sun early in the morning or late in the afternoon is about the most reliably attractive. It emphasizes landscape details such as trees, rocks, and hedgerows, makes gentle relief more prominent, and, most important of all, gives a wide choice of images in a short space of time. Stormlight, though unpredictable, can be dramatic if you are quick enough to take the opportunity of a break in the clouds, while mist and fog can give atmospheric, even abstract images.

Composition Traditional composition places the main focus of interest, and the horizon line (which naturally appears often in landscape photography), slightly off-centre – roughly one-third of the way into the frame from one edge. This gives a classic balance to the image, but a more eccentric position may be more exciting – a very low horizon, for instance, can heighten the sense of space in an open plains landscape. Changing the focal length or your viewpoint usually gives ample choice in composing a shot.

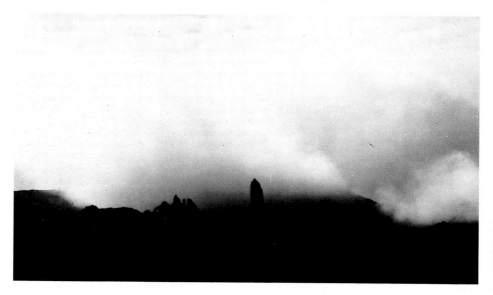

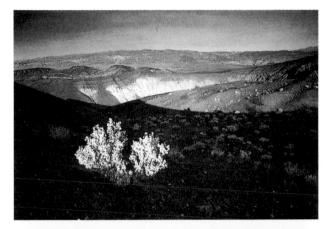

This view of Death Valley's Ubehebe Crater is essentially straightforward and literal, relying mainly on timing of the light to give interest to the design.

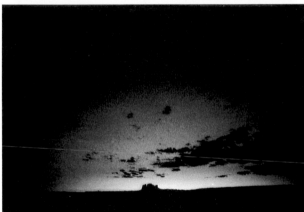

A less literal, more impressionistic treatment of a landscape in Utah uses twilight and a short exposure to reduce the information in the scene.

In black-and-white landscape photographs, the tonal qualities are often paramount. The shifting fog and cloud over this Scottish landscape make a good monochrome subject (left).

A 400 mm lens used from an overlooking mountain is used to select an abstract pattern from the shifting courses of a river in Northern Pakistan (right).

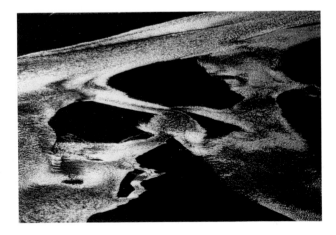

Landscapes: Focal length

Long focal length – distant views Long-focus lenses magnify selected parts of a scene, so that from one viewpoint it is often possible to make several quite different photographs. The sense of distance that a long-focus lens imparts is instantly recognizable, and tends to give a cooler, more objective quality to the photograph than would a wide-angle lens.

The characteristic effect on perspective is to compress it, making backgrounds appear relatively large. This foreshortening is particularly effective from a high viewpoint looking across a landscape of strong relief, with different ranges of hills or mountains – such a scene appears as a series of stacked layers. Long-focus lenses, by being selective, are also useful in picking out abstract details.

All long-focus lenses need careful use to avoid camera shake and flare, and to preserve depth of field, which is traditionally important in landscape photographs. The longer the lens, the greater the problems, and even though a rigid support, such as a tripod, is often essential, even a moderate breeze may move the camera. On windy days, use a low tripod position (see pages 150-1), and find shelter, if possible, behind a rock or tree; also use a cable release and lock up the instant-return mirror to lessen vibration.

Reduce flare by using a lens hood or by shading the lens from direct sunlight with your hand or a piece of card. To minimize haze, use a yellowish UV filter or, if the sun is at right angles to your point of view, a polarizing filter.

Short focal length – panoramic views Wide-angle lenses can reproduce the sweep of a broad landscape, particularly if used horizontally or cropped to give a long, narrow format (panoramic cameras, such as those shown on page 141, are often very good for this kind of landscape photograph, excluding unnecessary sky, and simulating the way that our eyes sweep over a horizontal scene).

A composition that includes small foreground details, which are exaggerated in size by a wide-angle lens, tends to draw the viewer *into* the scene. For this, complete

sharpness throughout the photograph is usually best, and although wide-angle lenses have inherently great depth of field, it may be necessary to use a small aperture. This in turn may need a slow shutter speed, and although there are fewer problems in holding the camera steady than when a long-focus lens is fitted, the movement of leaves and grass in the wind may cause blurring. If this is likely, make the exposure during a lull.

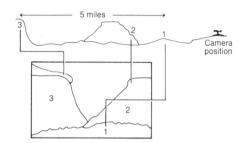

A long-focus lens, here 400 mm, emphasizes the vertical component in a landscape by squeezing together widely spaced subjects. Although separated by several miles, this table-top mountain and hills appear stacked together. Haze helps to separate the three planes (opposite above).

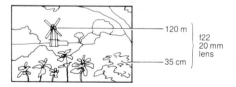

A low camera position, virtually at ground level, and a small aperture give an intimate view of farmland, emphasizing the details of the hedgerow and meadow. The windmill, which is prominent even though distant, balances the foreground and points out the great depth in the scene (opposite below).

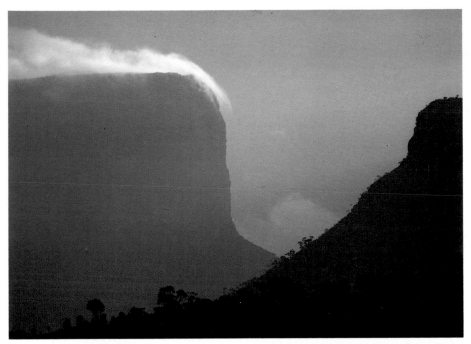

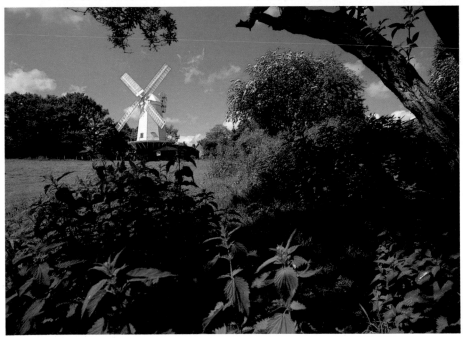

Urban landscapes

Whereas traditional landscape photography emphasizes natural, or at least rural, elements, urban areas have a wealth of varied material for the camera. Large cities, in particular, offer the same scale of views and perspectives as natural landscapes, with the important difference that the basic subject of the photograph is man's control over his environment. In this, urban landscape photography borrows something from both architectural and candid photography, but is distinct from both; individual buildings and people, when they appear, are components of the view rather than the sole focus of attention.

The principles of lighting, composition, and lens focal length are similar to those outlined for natural landscapes, with some special considerations. A good, clear viewpoint for an over-all shot of a city is usually top priority yet difficult to find, as nearby buildings, cables, lamp-posts, and other obstructions often get in the way. The most likely positions to investigate are:
☐ The upper stories or roof of a high-rise building. This often needs special permission
☐ Any high ground, such as a hill overlooking the town
☐ City parks, the larger the better
☐ The opposite bank of a river or lake, or from the sea
☐ An aircraft (in some resort cities, such as Miami, inexpensive short flights are run as a tourist attraction)

A low sun gives good basic lighting for a large proportion of city views, and as most urban areas have fairly polluted atmospheres, industrial haze in late afternoon often helps to separate areas of the view into distinct planes. It also improves the chance of attractive, glowing sunsets. Artificial lighting at night can be very effective (see pages 20-1 and 34-5 for examples). Shooting at twilight retains some details of the skyline and shapes of buildings, as well as reproducing the patterns of city lights.

As well as photographing over-all views of massed buildings, consider showing people in specific relationships to buildings

(such as a single figure dwarfed by an oil refinery), or visiting normally crowded streets when they are deserted, at dawn or on Sundays, or concentrating on small but significant street details that typify the character of a city.

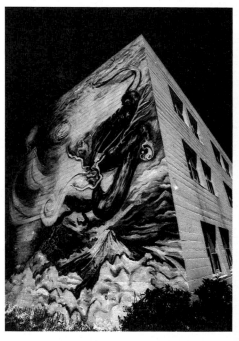

Certain details of buildings, such as this flamboyant mural in San Francisco, are characteristic of particular cities (above).

Unobstructed distant viewpoints give the possibility of scene-setting panoramas and, as here, selective views with a long-focus lens (opposite above).

Careful choice of viewpoint, directly over London Bridge, shows the morning influx of commuters succinctly and graphically (opposite below).

Buildings

Traditional architectural photography aims to give a clear, undistorted view of a building, roughly in accord with the architect's intentions. The creative element, in other words, belongs more to the architect than to the photographer. This applies to most formal designs of building, although there is still a fairly wide scope for treatment, varying the lighting and composition. With many modern buildings, however, unrestrained designs, often using large areas of glass and unusual shapes, free the photographer to explore graphic possibilities and even to create distortion deliberately.

Lighting Ideally, anticipate how a building will look under different conditions, and return when they are right for the image you want. The specific building and setting will determine this, but the two least satisfactory conditions are usually a high sun, which gives strong contrast, and a light cloudy sky, which increases flare. Floodlighting is often good, and a useful alternative if the daytime view is unsatisfactory, but may need care in filtration (see pages 20-1 and 34-5), and is usually best with some twilight.

Polarizing filters or, with black-and-white film, red and orange filters, deepen the tone of a clear sky to give the setting more contrast.

Viewpoint and composition Walk around the building at different distances and compare views. The focal length of lens usually depends on the viewpoint. Apart from a standard, frame-filling shot, also consider showing the building in its wider setting, and concentrating on details.

If there is difficulty finding a clear view, stand at the base of the building and look for distant viewpoints – if you can see a roof-top or hill, there is a good chance that it will offer a telephoto shot.

How to correct converging verticals We see most buildings by looking up at them from ground level. This makes vertical sides and lines seem to converge; this is hardly noticeable at the time, but seems unusual in a photograph. There are several ways of avoiding this, most of them depending on aiming the camera horizontally:

☐ Photograph from halfway up the building opposite
☐ Use a telephoto lens from further back
☐ Use a perspective-control lens, or shift the lens panel up on a view camera, keeping the camera level. This movement of the lens pulls the image down into the frame, so that the top of the building is not cut off
☐ Use a wide-angle lens, keep the camera level, and step back so that the whole of the building appears in shot. Crop off the unwanted foreground at the bottom of the picture during printing
☐ Use a wide-angle lens, also aimed horizontally, but compose to include interesting, relevant foreground detail
☐ Make a print, tilting the baseboard and enlarger head

Alternatively, turn the problem into an advantage by using a wide-angle lens and composing to exaggerate convergence. This is more likely to work with a modern building than a classical design.

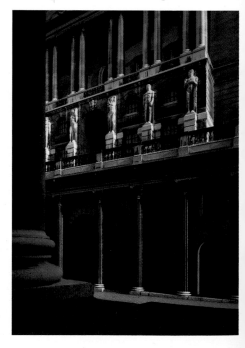

By selecting the essential feature of a building (here the façade of the Bank of England) and interesting lighting, even familiar architecture can be treated differently. Shift movements on a view camera were used to keep verticals parallel (left).

Modern office architecture usually has good graphic possibilities. A telephoto lens compresses the perspective and the shot was timed so that the shadow fitted exactly into the abstract design (above).

Architectural details, such as this fountain, offer a variety of shooting. In this case, a time exposure of a few seconds softened the appearance of the water (right).

87

Interiors

Capturing the sense and character of an interior, however large or small, depends first on finding a comprehensive view. No room can be taken in at a single glance, but a corner will generally give the widest view possible, with the help of a wide-angle lens. Choose the format – vertical, horizontal, or square – to suit the dimensions of the room and its most interesting parts. A chandelier or stucco frieze, for example, would argue for an upright picture.

Converging verticals are often even more of an issue inside a building than outside, because of the close viewpoint. Most of the techniques on pages 86-7 apply, but if you can rearrange furniture to fill empty foreground space, this is probably the easiest.

This is the formula approach – corner view, wide-angle lens, corrected verticals – but variations may be more interesting, particularly in large, cavernous interiors. A strongly angled view to show more of the ceiling is perfectly valid and gives the chance of interesting compositions with diagonal lines. Even with the standard approach in mind, it is worth experimenting by checking all the possible views.

In large public interiors there is likely to be no choice of lighting – what exists will have to do – but where you do have some control, the basic alternatives are firstly, daylight or artificial light, and then, either of these or photographic lamps. Adding special photographic lighting involves more effort, but it does mean that you can

When the only source of light is a single window or doorway, the illumination across the room is very uneven. Shooting against the light, as here, overcomes this problem, but severe contrast may need careful printing. Foreground details are useful; in this Peruvian café, reflections from the cobbled floor were an obvious element.

design the final effect to suit the film and your ideas. On the other hand, the atmosphere of an interior depends greatly on the normal lighting, and is often designed with this in mind. Casually adding extra lighting can easily destroy a balanced effect.

Using daylight only
- [] Unless there is a large skylight or windows all round, the light falls off quickly from one side of a room to another
- [] If the light comes from one side of the picture, use a neutral graduated filter to even out the contrast. With negative film, shade during printing
- [] Views with the window directly behind the camera are often flat and less interesting
- [] Shooting directly towards a window loses detail, but the back-lighting often adds atmosphere, particularly if the exposure is sufficient to flare the window

- [] A useful way of filling a dark, underexposed part of the picture is with a light foreground object, such as the open pages of a bible in a church

Using artificial light
- [] Many interior lamps create pools of light amid deep shadows. Dusk, when there is some daylight weakly filling in the dark areas, may be a better time to shoot than night
- [] To balance the colour, see pages 22-3

Using photographic lighting
- [] In a large interior, it may be more convenient and practical to work in comparative darkness, leave the camera's shutter open (use a tripod), and walk around firing off a flash from several concealed positions; keep yourself and the light out of view: stand behind columns, around corners, and so on
- [] For the standard procedure of setting up lights, see pages 90-1

Ceilings Some ceilings may be sufficiently interesting and important in themselves to merit a separate shot. For a distortion-free shot, attach a spirit-level to the camera and, if possible, a focusing screen etched with grid lines. First align the camera vertically with the level on a tripod, and *then* position it for the view of the ceiling (centred is usually best). Use a wide-angle lens for an over-all view, a telephoto for a detail.

Stained glass For the best result, stained glass needs even back-lighting. Daylight is easiest, but be careful of a blue sky behind; it will tint all the colours strongly. Expose for the window, not the interior. An upward view to a high window causes converging verticals, but this will be less obvious in a detail shot with a telephoto lens.

Interiors: Simple lighting

Not all interiors need elaborate lighting, and ordinary domestic interiors often need no more than one fill-in light, either a portable flash or a photoflood lamp. A single light, bounced off a wall or ceiling, is very effective in a small room with a low ceiling, the more so if the over-all decoration is bright. Fill-in lighting is usually necessary because most domestic interiors have windows in only one or two walls.

The treatment will vary from room to room, but the following sequence is a basic procedure that applies to most:

1. Choose the viewpoint and lens. Corners give the widest view, helped by a focal length between about 20 mm and 24 mm on a 35 mm camera. Beware of shapes that will show distortion at the corners of the picture, such as table clocks. Shooting towards the window often makes the view more interesting, but will need more care in controlling contrast and colour balance.
2. Alter the positions of furniture to suit the composition. Aim for simplicity.
3. Tidy up, clean, and polish.
4. Decide on the *main* light source: sunlight, cloudy daylight, a photographic lamp (flash or photoflood), or a mixture. Choose the time of day accordingly. If you rely on daylight, use portable flash as fill-in; otherwise, a photoflood lamp is easier to use (you can see the effect).
5. Choose a colour balancing filter to match the main light to the film (see pages 22-3), but also use others that are cooler and warmer.
6. Use room lights for effect only; their illumination is nearly always too uneven for a photograph. Don't use fluorescent strip lights; they will appear green on film.
7. Use fill-in lighting to lower the contrast of the whole picture. From one side of the room to the other, the difference in brightness should not be greater than one stop, unless you want a stark, unusual effect.
8. Bracket the exposures.

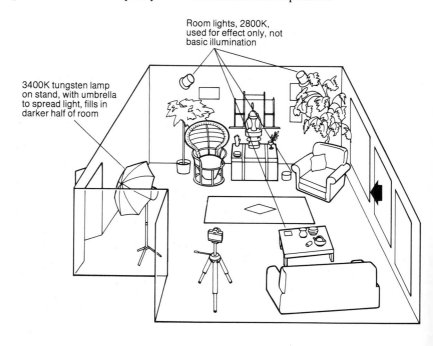

Room lights, 2800K, used for effect only, not basic illumination

3400K tungsten lamp on stand, with umbrella to spread light, fills in darker half of room

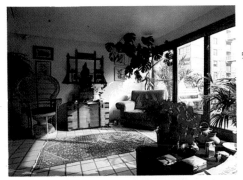

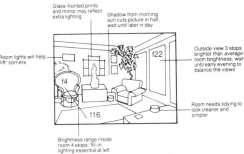

Glass-fronted prints and mirror may reflect extra lighting

Shadow from morning sun cuts picture in half; wait until later in day

Room lights will help 'lift' corners

Outside view 3 stops brighter than *average* room brightness; wait until early evening to balance the views

f22

f4

f16

Room needs tidying to look cleaner and simpler

Brightness range inside room 4 stops; fill-in lighting essential at left

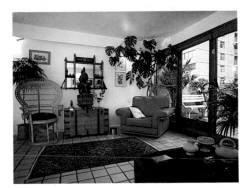

Before Lighting too contrasty, room untidy, composition cluttered and unstructured (left).

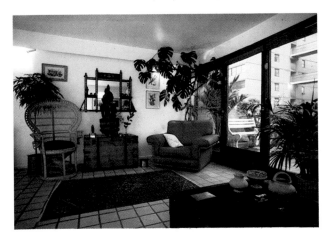

After With all the necessary adjustments made, the final photograph is balanced and uncomplicated. To have lit the room entirely by artificial light would have needed several lamps, but by mixing tungsten with daylight, only one fill-in light was needed. The precise timing, as dusk approached, was important for the right balance, and because the most attractive colour balance was uncertain, the filtration was bracketed on daylight film, from no filter to 80B. A very pale blue 82 filter was used for the main photograph (centre), and a stronger 80B for the photograph below. Both are acceptable.
Daylight film ISO 64: ½ sec at f5.6

91

Candid photography

Photographing people without their being aware of the camera makes it possible to show natural expressions and behaviour, undistorted by self-consciousness. However, being unobtrusive requires skill and tact, together with a number of techniques aimed at concealing, rather than advertising, your presence. Some of these are set out here.

☐ Dress and act so that you merge with the setting. Keep cameras out of sight except when shooting, and use a bag that does *not* look like a custom camera case

☐ If you can, use equipment that is quiet, light, and small. Some SLR cameras are noisy, particularly when used with winders or motor-drives

☐ Long-focus lenses make it possible to shoot at a distance. Focal lengths between 135 mm and 200 mm are popular for street photography, but from a concealed position a 400 mm or 500 mm lens can give close views unobtainable any other way. The maximum aperture, often small with telephoto lenses, is a major limitation, as it restricts the shutter speed. Aim to use at least 1/250 sec most of the time, although a slower speed may work when people are moving slowly

☐ Wide-angle lenses have such good depth of field and coverage that they can be used rapidly, often without focusing, making it possible to take at least one shot from a close distance before you see any reaction from your subject. If you aim off with a wide-angle lens, the person you are photographing may not even realize that he or she is the subject

☐ Doorways, windows, balconies, pavement cafés, or even the shaded side of a street offer some measure of concealment. High camera positions are particularly unobtrusive

☐ Waist-level shooting is often not recognized as such, even by someone looking directly towards the lens. With a 35 mm camera, simply remove the prism head. An effective technique is to pretend to be cleaning the camera, or to aim it to one side

☐ If you have decided on a fixed setting, such as a doorway, and are simply waiting for someone to pass by, remote control may be worth considering, even using an extension cable. You could even hide the camera under your coat

Preparation Anticipation and quick camera handling are essential skills in order to be able to capture the transient expressions and incidents that are the prizes of candid photography.

☐ Anticipate the focus and exposure settings for every situation, changing them if necessary as you walk around. Automatic exposure can help, but on most cameras it makes it difficult to bracket (see page 31) or to compensate quickly for a contrasting background. Check that the speed is at least 1/125 sec

☐ Regularly check the film counter, and have a fresh roll to hand

☐ If you are uncertain of the exposure, bracket quickly as you shoot, by either a half or one stop up and down

☐ Limit the lenses that you carry as much as possible, but use fast ones. A 180 mm f2.8, 35 mm f1.4, and 24 mm f2 would, for instance, be a reasonable selection

A long telephoto, in this case 400 mm, adds problems of weight and shutter speed (because of the smaller maximum aperture), but makes unobserved shooting relatively easy. As photographs can be taken at a distance, it is usually possible to wait for just the right moment of expression.

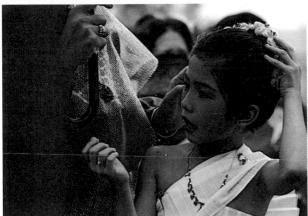

A more normal, and easier-to-use lens for candid photography is a medium telephoto such as 180 mm. In fluid situations, here a festival in Eastern Thailand, such a lens is good for quick reaction shots in open crowds at distances of a few metres.

Wide-angle lenses can be used for candid shots at very close distances, their good depth of field removing the need for delicate focusing. Being near to the subject, however, means that shots must be taken very quickly. By framing the picture so that the subject is off-centre, the photographer may appear to be shooting elsewhere.

Outdoor portraits

In portrait photography, even if it is impromptu, it is essential not only to have the full cooperation of your subject but for you, as the photographer, to control the session firmly. Nothing weakens the mood of such an occasion faster than indecisiveness. Most people *want* to be told where to sit or stand and how to behave in front of the camera.

If you have the opportunity, plan the place and time in advance, having first decided on a suitable setting and light. Otherwise, simply do the best you can with the situation at hand, but act quickly. If the person you want to photograph is not wholeheartedly enthusiastic, an instant print can work wonders in encouragement.

Setting All portraits need a background, however simple. The basic choice is between a setting that is unobtrusive, such as a wall, the edge of woodland, or a lake, and one that is relevant, such as a place of work or home. If the physical features of a face are striking, a plain background may be sufficient, but if your subject is involved in some interesting activity, the surroundings may be essential to the image.

Lighting Hazy sunlight is probably the most efficient natural light for portraits. Hard direct sunlight gives strong facial shadows and is usually best avoided. For black-and-white photographs, open shade is attractively diffuse, but with colour film, be careful that the light is not from a blue sky, otherwise the portrait will have a blue cast unless you use a CB filter (see page

If the background is neither suitable nor attractive, tight framing is likely to be the best answer. Using a medium telephoto lens, this shot is framed to include all the important features of a head-and-shoulders portrait – face, hair, dress – without showing anything of the distracting setting.

48), the strength of which may be difficult to judge.

One answer to the problem of open shade is to place your subject close to a white sunlit wall, or to use a reflector made of white card or crumpled aluminium foil.

For back-lit portraits against a bright sun, fill-in flash (see pages 28-9) will lower the contrast.

Composition Most portraits fall into these few categories:
- [] Head shots, tightly cropped to concentrate attention on the eyes and mouth
- [] Head and shoulder shots
- [] Three-quarter shots, showing just the head and torso
- [] Environmental shots, showing the

subject firmly in relevant surroundings

For the last of these, a wide-angle lens can help to link subject to setting and has sufficient depth of field to make the whole image sharp, but for the closer compositions, a long-focus lens gives a truer perspective, without making the nose and chin appear too large; for a 35 mm camera, lenses between 85 mm and 200 mm are useful. Long-focus lenses have shallow depth of field, however, so that not all of the face may be sharp. The safest method is to focus on the eyes.

Filters To flatter a face, a mild diffusing filter softens the features and obscures lines and blemishes. With black-and-white film, a red or orange filter reduces any red blemishes.

Any relevant, interesting activity can be a useful prop for a person who would not feel completely at ease in a straight portrait. Here, placing the girl and lamb against an unlit doorway simplified the setting.

Indoor portraits

Indoor settings are often more relaxed and interesting for portraits than outdoor locations. People usually feel more secure and confident on home ground, and although lamps and reflectors take time to set up, control over the lighting goes a long way towards guaranteeing an effective portrait.

How much and what kind of lighting is, in fact, the main technical question. Daylight from a window may be sufficient on its own, or some lighting may have to be added. It may even be better to build a lighting set-up from scratch. Avoid the danger of lighting equipment taking over the session by deciding promptly which of these three approaches to go for:

☐ Natural daylight with shadow fill-in

☐ Existing room lamps, strengthened with extra lights

☐ Photographic lamps only

Which to choose depends on the way the room is laid out and decorated, and also, of course, on the type of portrait. A close head-and-shoulders view needs just one thing: a fairly broad light source and some means of lightening the shadow side of the face. Any of the basic lighting arrangements shown here will do, but more control is possible by blacking out the room and using only photographic lighting – in other words, a studio portrait. Three-quarter and full-length portraits can also be made with full studio lighting, particularly if the backdrop is provided specially, such as a standard paper background roll or selected props.

An alternative is the natural room setting, and this is always worth considering if it is attractive or is relevant to the person being photographed. Look at the type of work your subject does, or his hobby or some other special activity; any of them might be the inspiration for an interesting shot. Even the shyest of people can be helped to relax if you ask him or her to perform some activity. For this kind of shot, it is usually easier to let the existing lighting dominate – daylight from a window, or the room's own lamps. If neither is bright enough to allow a reasonable shutter speed, add photographic lights. In any case, use reflector cards or soft lights to fill in the shadows.

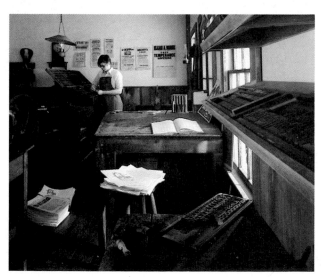

Lit entirely with photographic tungsten lamps, some of them positioned outside windows in order to simulate daylight, this shot of a typesetter in an old printing shop favours the setting rather than the person, using a wide-angle lens to establish the context (left).

While daylight appears to be the main source of illumination in this tiny studio, a large flash unit, diffused through a translucent umbrella, provides unobtrusive fill (right).

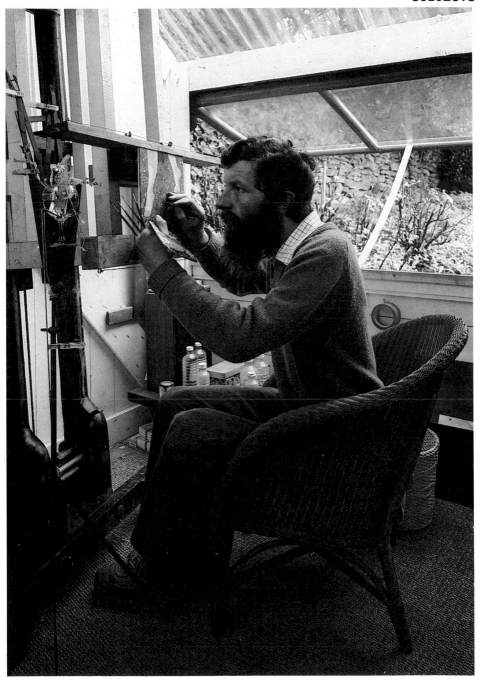

SUBJECTS/INDOOR PORTRAITS

Six ways to make a portrait more attractive
- [] Use a medium telephoto lens
- [] Diffuse the light heavily. If it comes from a window, hang net curtains or tracing paper; if it is a studio light, aim it from over the camera, and have the sitter hold a sheet of baking foil like a tray, to kill shadows
- [] Have the sitter lean slightly towards the camera
- [] Shoot plenty of film: it encourages the sitter that the session is going well
- [] Keep a conversation going: it will help to animate the sitter's expression
- [] Vary the poses: as well as full-face, try three-quarter profile, sitting at an angle, and turning the head towards the camera

These four different lighting styles cover the range of normal indoor portrait shots:

1. Natural daylight
- [] Shoot close to the window for the broadest light
- [] Cloudy weather or sunlight through net curtains gives softer light
- [] Fill in shadows opposite with large white cards, crumpled foil stuck on card, or a photographic lamp bounced off the opposite wall
- [] If the light level is too low, add either flash or a tungsten lamp covered with a blue gel; bounce this light off a large white card outside the window, or simply bounce it straight off the glass from inside

2. Existing room lights plus
- [] If tungsten lamps, use Type B film; if fluorescent lamps, use daylight film with an F1 or 30 magenta filter
- [] Raise the lighting level by bouncing photographic lights off the ceiling
- [] Possibly add shadow fill-in with a strongly diffused side light (an umbrella or bounced off a white card or wall)
- [] The colour balance of the photographic lights does not need to be exactly the same as the room lights, but should be close: for example, use photofloods with existing tungsten lighting, flash for fluorescent if the camera has a filter
- [] For other lighting alternatives, see pages 22-3

3. Basic studio lighting
- [] One well-diffused main light (umbrella or window light); typical position is fairly high, fairly frontal
- [] Plenty of shadow fill-in at the sides and underneath the face; use white card, crumpled foil, a lamp bounced off a large white card or through a trace frame
- [] Effects light from high and behind, to highlight hair (optional)
- [] Separate background light gives clear-looking backdrop

4. Full-length studio lighting
- [] Very broad, diffuse main light, from one side (ideally, should be the size of a standing person)
- [] Large reflector opposite to fill in shadows
- [] Light the backdrop evenly with two lights, each aimed across the subject from one side

A person involved in some activity is a straightforward device for a relaxed portrait; this French chef in her restaurant is at home and self-confident. Tungsten lamps, diffused and with blue gels to bring them closer in colour to the daylight, provide the illumination (left).

Completely artificial lighting – a mixture of photographic tungsten and the room's own, warmer, tungsten chandeliers – here allows full control over a carefully posed, formal, full-length portrait of a girl in period dress (right).

Children

Photographing children can be as easy as watching them play, or as difficult as persuading them to eat a meal they don't like. There, in fact, lies the secret of capturing charm and interest in a picture: catch children at moments when they are absorbed in something that interests them. A planned portrait *is* possible, but only just, and by far the best occasions are the natural ones, even if they have to be set up with a little subterfuge by the photographer.

The candid approach is one of the best, provided that the situation is right. 'Candid', in fact, doesn't really have that meaning with children, as inhibitions about privacy are mainly an adult preoccupation. Children at play, on an exciting visit (such as to a zoo), or at an organized event such as a fancy-dress party – all these are easy occasions for standing back and taking carefully observed shots. Quieter moments, like a child absorbed with a new toy or teaching a puppy to fetch a stick, need a little more discretion, and a long lens helps.

A portrait session will only work as long as the child stays interested and sees a point in the whole proceedings. The technicalities of lighting, background, and camera settings are quite rightly boring for children, and best worked out beforehand. Keep the session fun, perhaps by involving the child in the picture-taking (sometimes a Polaroid is useful), or by having an interesting prop such as a toy or game, or by getting the child to show you or tell you about the latest craze.

Despite being unpredictable, unposed groupings such as these young Filipino girls, offer more spontaneity than formal arrangements (left).

Catching a good moment during a child's play may mean waiting – a long-focus lens from a distance allows quiet observation (opposite above).

Occasions and performances – here Hong Kong's annual bun festival – absorb children's interest and allow unselfconscious close-ups (opposite below).

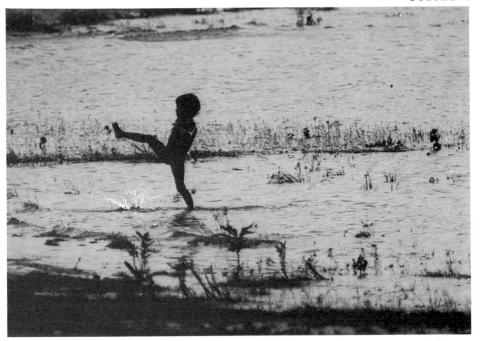

Festivals

Parades and other kinds of public celebration are rich in photographic possibilities of all kinds, from showing the scale of the spectacle to unusual details. Making interesting images is not difficult, but finding a good viewpoint and being able to work quickly are essential. All festivals are organized to some degree, and for a successful coverage any photographer must be at least as well organized. There will always be competition for good places from which to see what is going on, and only preparation guarantees a better camera position.

Preparation check
- ☐ Find out the basic details: date(s), timing, route, programme. Contact the organizers
- ☐ If possible, go over the route beforehand; if there is a rehearsal, try to be there
- ☐ Try to get a special pass (these are often available for photographers, and not always restricted to professionals)
- ☐ Find a clear view of the main event – the centrepiece of the festival; make sure that you will be in front of or above any crowds, but bear in mind that some positions, like traffic islands, may be closed off on the day
- ☐ The best view of a parade is likely to be head-on with a telephoto lens: a bend in the road often gives this
- ☐ The windows and balconies of private houses overlooking the route are usually excellent positions; ask permission early

On the day
- ☐ Take plenty of lenses and film, but only what you can carry
- ☐ Be in position early, before the crowds
- ☐ Don't overshoot at the beginning; cover the basic shots, then try to improve on

At least one shot should show a large part of the event from a distance. For this picture of the Bangkok bicentennial celebrations, a 600 mm lens compressed the activity.

what you have (better timing, better composition, etc.)
□ Look for variety: of subject (see below), lens focal length, colour, tone, etc.
Once you have the key shots you planned for, move around if possible and look for different subjects and viewpoints

Shooting possibilities
□ Centrepiece of the occasion
□ Head-on long-shot of parade
□ Tableaux
□ Packed crowds from above
□ Fancy dress
□ Individual shots of people enjoying themselves
□ Spectators' faces
□ Behind-the-scenes preparations
□ Quirky asides and odd moments (these are impossible to predict, but people sometimes behave in strange ways at these events)

Interesting views, such as this of the Venezuelan flag at May Day, are usually possible.

For most important shots at a festival, a viewpoint above crowd level is important (top).

Action and sports

Fast action always has the potential for excitement in a photograph. Often the subject itself is dramatic – a violent play in a game of football, or two racing bikes taking a corner together – but also the very sensation of movement in any situation can bring an image to life.

Action naturally demands sharp reflexes and good camera handling (see pages 68-9). In addition, because there is no time for indecision at the moment of shooting, being familiar with what is about to happen gives the edge in catching the telling instant. The more you know about a sport, the better pictures you ought to be able to take.

The essentials in action photography are as follows:
□ Anticipate the action; if possible, watch a run-through first, say at a rehearsal
□ Be in the right position; check that you have a clear view of where the action will take place
□ Have the right shutter speed and right lens; set all the camera controls in advance, to save time
□ Catch the peak; know where and when the climax of each burst of action will happen

Of all the technical points, knowing the most effective shutter speed is probably the most critical. High shutter speeds can only be achieved by sacrificing depth of field (with a wide aperture) or sharp detail (with a fast, grainy film), or both. So using a speed faster than absolutely necessary is very much a waste. See pages 66-7 for a guide to the speeds.

Six ways of freezing action
□ Pan the movement to keep the subject steady in the frame
□ Shoot on-coming movement (this needs a slower shutter speed than side-to-side movement)
□ Use fast film, pushing it if necessary, to allow a high shutter speed
□ Over short distances, use flash
□ Shoot at slower moments in the action: an athlete at the peak of a jump, a racing car at a bend
□ Make the image smaller (by stepping back or using a shorter focal length lens), and enlarge it later

A long lens, good position and anticipation are essential at sports events.

Six ways of making action seem faster
□ Use a slow shutter speed
□ Pan at a slow shutter speed to blur the background
□ Zoom and pan – that is, work the zoom control on the lens as you shoot
□ With available artificial lighting, use a slow shutter speed to streak the image and flash to freeze it, all on the same frame of film
□ Make several shots on the same frame by holding in the multiple-exposure button (on some cameras) and shooting with a motor-drive (this works best against a dark background); reduce the aperture to compensate for the extra exposures
□ Use strobe flash in order to produce a multiple image against a dark background; reduce the aperture to compensate for the extra exposures if they overlap

Rapid sequential shooting makes it possible to catch the clearest moment in an event: here as a surfer is outlined against the white spray. Minimum shutter speed 1/250 sec.

Planned, repeatable bursts of action, such as these dolphins leaping in a marine park, can be anticipated by watching previous runs. Minimum shutter speed 1/500 sec.

Impromptu action, in this case a rather drunken celebration during a rocket-launching contest in Thailand, is usually best handled with a fast, wide-angle lens that can be aimed rapidly. Minimum shutter speed 1/500 sec.

Wildlife

Not surprisingly, with what is a fairly specialized area of photography, knowing the habits and behaviour of the animals takes first place. Most animals are, for their own safety, wary and elusive, so that most of the techniques of wildlife photography are simply to do with capturing a reasonably large, clear image. These techniques vary from animal to animal, but the objectives are always the same. In order, they are:

☐ Find the animal
☐ Get close enough for a worthwhile image
☐ Show the animal doing something interesting
☐ Make the picture as aesthetically interesting as possible

Equipment depends on the species, but the two essential items are a telephoto lens for larger animals and a macro lens for insects and the like. Many of the most interesting animals can only be photo-graphed with a lens of at least 400 mm; wildlife photography is one field that admits little compromise in equipment.

The right place at the right time Chance encounters apart, the key to successful wildlife photography is finding the best location for the particular animals. 'Best location' for photography means not only that a species lives there in reasonable numbers, but also that the animals are visible and approachable, and that there are facilities such as hides and established water-holes. Most of the best are wildlife reserves and national parks; deciding which to visit involves research:

☐ Use libraries and bookshops for guide books, species field guides, and magazine articles (especially *National Geographic, Geo*, and wildlife magazines); existing photographs are the best clue to accessibility
☐ Ask conservation and wildlife organizations, both national and local

☐ Check the best season for the greatest concentrations of animals, and avoid dates when, for protection (such as during nesting), areas may be closed to the public; migration 'corridors' and stop-overs can be spectacular

☐ Check the best times of day: many animals are most active in the early morning and evening

☐ Ask local experts, such as park wardens, for specific locations such as water-holes and feeding areas

☐ Most animals are more difficult to find in rainy or stormy weather; fine bright weather also allows higher shutter speeds and longer, slower lenses

Close approach Check in advance the strength of telephoto lens that will be needed for a well-framed shot. This naturally depends on how close you can expect to get to an animal, and how large it is. Generally, the longer the focal length, the better (at least 300 mm or 400 mm in most situations), but a heavy lens may not be portable enough.

Most animals will not tolerate a very close approach, so stealth and concealment are essential. *Stalking* involves moving lightly and silently, using available cover, and requires skill. An alternative is a *hide*, which is a camouflaged shelter that allows longer observation at a well-visited site, such as a feeding-ground. Some wildlife reserves have permanent hides to which the animals are accustomed; introducing a temporary one demands experience. In some locations a *vehicle* is suitable as a kind of movable hide: as long as its occupants stay inside, it is not seen by animals as much of a threat.

Specific tips include the following:

☐ Most animals use scent or movement as a means of detecting threats and prey; stay downwind of them when possible, avoid perfumes and deodorants, and move slowly

Although close, tight shots are the standard fare of wildlife photography, any opportunity to show animals in their settings is valuable, provided the composition can be made clear and simple, as in this view of Serengeti elephants sheltering under an acacia (left).

Unusual activity (cheetahs very rarely climb trees) is aways worth photographing. Knowing what is unusual requires some experience (right).

- [] Wear drab-coloured clothing, and dull bright parts like chrome camera fittings and shiny skin
- [] Keep quiet, and carry nothing that rattles
- [] When stalking, avoid sunlight, skylines, and open ground
- [] In sight of an animal, move only when it is busy (say, in the process of feeding); stop when it looks up
- [] If the animal notices you and becomes tense, stop immediately and freeze for at least a few minutes

Behaviour The most interesting and useful wildlife photographs are those that show animals doing something. Static portraits (zoos abound in these) are rarely as satisfying. Field guides usually indicate typical behaviour, and it helps enormously to know what to expect. Activities such as feeding, courtship, nest-building and aggression, and action (running, jumping, flying) are all worth the effort of planning and waiting for.

Wildlife imagery It is easy to be so preoccupied with capturing *any* kind of clear picture of an elusive animal that the normal creative standards of photography get little attention. Yet wildlife photography should be more than simple record-keeping, and what sets a good picture apart from the average is usually its qualities as a photograph – capturing an apt moment, evocative lighting, dynamic composition, and so on. By all means concentrate on the fieldcraft and technique in order to be in a position to shoot, but once you have the opportunity, try and make the best image out of it:

- [] When time allows, shoot at the elegant or telling moment in an animal's activity: most wildlife photography is candid photography, and a sense of timing and observation is just as important (see pages 92-3)
- [] Silhouettes, misty views, and other atmospheric treatments bring visual variety
- [] Pulling back to show the animal in its surroundings may make a stronger picture than a tightly cropped view
- [] Look for interesting, off-centre compositions rather than always framing an animal in the middle of the viewfinder

Almost without exception, masses of one species can make spectacular images. A long-focus lens and a slightly elevated viewpoint are the usual method (above).

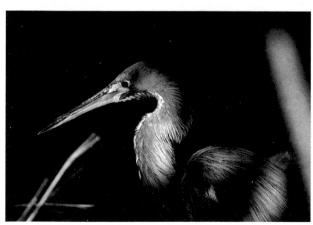

Stalking is a suitable technique for photographing many animals that are active by day, large enough to fill the frame from a few metres, and live in habitats that have a reasonable amount of cover. This Louisiana heron was photographed with a 400 mm lens (left).

Close-up

Few people pay close attention to tiny objects; eyes, like most camera lenses, focus best *beyond* several inches. As a result, the perspectives of close-up images are unfamiliar and can make intriguing photographs. Anticipating the way a magnified image will look is not the same as visualizing a normal, large-scale scene, and one of the best ways of constructing a close-up photograph is by experiment, through the viewfinder.

Because of its capacity for unexpected images, close-up photography has a limitless range of subjects. Nature is one of the richest and most obvious sources, including flowers, small plants, and insects; another is the world of miniature electrical and mechanical components. Apart from these, however, the surfaces and other details of large objects can also yield interesting images; hence the value of experimenting.

Stylistically, most close-up photography follows one of three treatments:

1. A clear image of a miniature subject. This relies heavily on accurate technique to give what is essentially the kind of view familiar at normal scales – sharp, with balanced lighting.
2. An exploratory view that makes the most of the unfamiliarity of close-up images. Unusual choice of subject-matter, viewpoint, and lighting are common techniques.
3. An abstract image. Small changes of viewpoint vary composition enormously. This, and the extremely shallow depth of field at full aperture, make it easy to concentrate on the graphic, abstract elements.

Greater technical precision is needed in close-up photography than at normal scales, and the danger of this is that the calculations may take up time and attention better spent on simply making good pictures. A simple, refined system for managing the major technical problem – exposure – is set out on pages 32-3, while

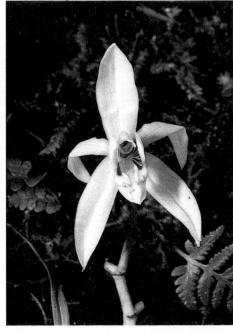

For a conventionally documentary shot of a small orchid, the most basic and reliable of close-up equipment was used: a macro lens focusing down to half-life-size magnification, and a dedicated flash-gun with downward-tilting head. Such an arrangement is about as foolproof as it is possible to be.

the full details are laid out in the tables on pages 160-1.

Equipment Up to a point, supplementary close-up lenses are very convenient. Attached to the front of the camera's lens, they need no extra exposure, and can be fitted and removed easily. The three most common strengths are +1 diopter (the weakest), +2 diopters, and +3 diopters, and they can be combined. However, at magnifications greater than about 1/6×, image quality suffers. Split-field close-up lenses are a variation which cover only the lower half of the lens; the top half is clear, allowing a close subject and far background to be focused at the same time even at a wide aperture.

The usual way of magnifying is to move the lens further away from the film (which is how a normal lens focuses). Macro lenses have a specially long focus travel, and magnify up to about ½× without attachments. Otherwise, either extension bellows or extension rings can be fitted between the lens and camera body. Bellows allow a wide range of magnification but are delicate and slow to use; extension rings allow only fixed magnifications, but are rugged and convenient for outdoors.

At magnifications greater than life-size, image quality is better if the lens is reversed, using a special ring. For all kinds of close-up photography, macro lenses are sharper than regular lenses, although the differences may not be very marked.

Lighting At the small scale of close-up photography, ordinary lighting appears more diffuse than normal. High contrast and deep shadows are rarely a problem, except with small flash units, and natural light is often perfect. Small reflectors, such as pieces of paper, card, foil, and even dental mirrors, allow full control.

Flash lighting may be needed with an active subject and to overcome long exposures, but its major problem is that the results are difficult to anticipate. A Polaroid test shot is useful (see pages 56-9).

At a magnification of ×2 (using a 55 mm macro lens at its full extension) it was possible to crop into this orchid so tightly that all background references could be excluded.

Close-up subjects need not always be photographed 'as is', but can be assembled exactly as any still life, though on a miniature scale. This collection of small shells was arranged as a mass to simplify the composition, but with a few placed strategically for balance. A well-diffused studio flash provided the illumination.

An experiment in confusing the scale. This photograph of a fluorite crystal appears on this page four times larger than the original, yet has a more spacious feeling. This is achieved by using a small tungsten light (for sharp shadows) and unusual sharpness through using a view camera tilted to redistribute the focus (see page 158).

Using an extension bellows or ring cuts down the light reaching the film. This must be allowed for each time, or the photograph will be too dark. Increasing the aperture is one answer, but as shallow depth of field is already one of the restrictions in close-up photography, this is often not practical. Quite the contrary in many instances, as a small aperture is needed to help the over-all sharpness, thus cutting down the light even more. The two usual alternatives are long exposures or adding more light (that is, using flash in most cases). Because of the permutations of exposure, magnification, light intensity, and so on, the calculations can be labyrinthine. They are given, in all their complexity, on pages 160-1, but for most situations the methods shown here will work perfectly well.

Calculating exposure By far the best method is *not* to – by using instead an SLR with a TTL meter. Eventually, all cameras will have this feature, but for those that

still do not, the easiest solution is to use the chart printed on pages 160-1. Full calculations are also given on these pages.

An added problem may be that the exposure is so long that the film's speed and colour change slightly. If you use daylight film at speeds slower than about 1/8 sec, check on pages 40-1 to see if any extra allowance has to be made.

At all long exposures, make sure that the camera is steady and free from vibration. For instance, lock up the mirror, and shield the subject from any breeze.

Using flash When there is insufficient natural light, and when the subject is moving, flash is usually necessary. Previewing the result is not possible, so some testing and experience are essential. Make sure that the end of the lens does not get in the way of the light, and for balanced lighting use a reflector or second flash opposite.

By far the best solution, which cuts out all calculations, is to use a dedicated flash

unit with a camera that has TTL flash metering. Otherwise, use the chart printed on page 161, in exactly the same way as the other chart. Take these precautions:

□ At these close distances, guide numbers do not mean what they do at normal scales; make a test and expect to allow an extra ½ stop

□ Do not use the automatic circuitry on the flash; it will not work properly over only a few inches

□ For simplicity, the chart shows how far away to place the flash (an alternative is to vary the f-stop: see pages 160-1)

□ Bracket exposures for safety – better still, test first

Depth of field In close-up photography, depth of field is shallower than at normal distances, and the greater the magnification, the more difficult it is to keep everything in the picture sharply focused. This is usually a problem, but in abstract images the shallow focus can have some virtue. Also, shallow focus helps to sepa-rate a subject from its surroundings, so don't automatically try and improve it.

When depth of field *is* important, these are the ways of making the most of it:

□ *Use a small aperture* The penalties are that much more light is needed and that the focused parts of the picture may lose a little sharpness

□ *Use the pre-view button* On an SLR this gives some indication of the results, but the view will be dark; in close-up, depth of field is about the same distance in front of and beyond the point of focus (for real accuracy, use the table on page 160)

□ *Choose a side-on viewpoint* Composition apart, arrange the subject in such a way that, front-to-back, it is as shallow as possible

□ *Use swings and tilts* Some extension bellows have swing and tilt movement, which change the angle of the plane of focus; align this plane of focus with the longest part of the subject

Still-life

Still-life is a long-established artistic tradition that has been easily and naturally absorbed by photography. Its essence is control, from the choice of subject to the finest detail of lighting, and all creative decisions are firmly in the hands of the photographer.

At times, still-life photography has languished in mediocrity, with much more attention given to craft than to imagination. At the moment, however, it is undergoing something of a revival in advertising and art photography, and although much still-life is content with being decorative, some of the most interesting work stretches the definition beyond the obvious. Some of the most prominent types of still-life photography are:

☐ Clear portraits of objects, efficiently lit and composed. Although not particularly imaginative, this kind of image is the most common. Accuracy and detail are relatively important

☐ Recreations of small sets. Typically, this kind of shot tries to evoke the atmosphere of a certain period or place, through careful choice of props and style of image

☐ Graphic experiments. Shots that concentrate on the two-dimensional elements: combinations of tone, colour, line patterns, and so on

☐ Illusion and surrealism. Tricks of perspective, lighting, and such special effects as suspending objects in mid-air and models are used to play games with the unquestioned realism that is usually attributed to photography

☐ Imaginative illustration. In publishing and advertising there is always a

Probably the most straightforward style of still-life, well suited to clear documentary views of objects, is a slightly downward-looking shot on to a plain white background, lit by a single, diffused, overhead light. Shading the back of the light gives a graduated darkening to the background (left).

By contrast with the uncomplicated still-life opposite, this individualistic view of a light-bulb employs close-up, a double-exposure through two differently coloured filters, and a deliberate vertical movement to the camera during one exposure. The result is an unusual experiment with a very ordinary object (right).

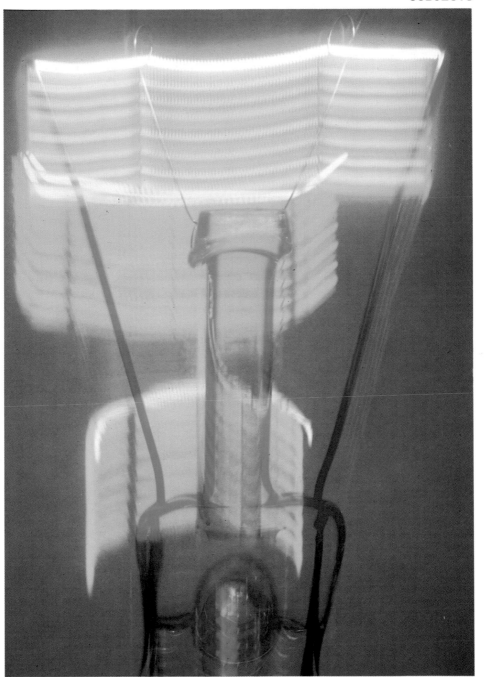

demand to visualize difficult or abstract concepts. By juxtaposing different objects and other techniques, still-life photography can illustrate ideas

☐ Experiments with content. This is largely the province of art photography in still-life – questioning accepted standards of what should be photographed. The best of this work is often a little uncomfortable

Subjects Although the starting-point for many still-lifes is simply an object that has to be photographed, the freedom to choose the subject is an opportunity to experiment. Literally anything of manageable size can be chosen, and an unlikely or unusual object gives the chance to be eye-catching. Technology, as just one example, is a rich source. Even such mundane objects as household items can, if handled imaginatively, be interesting just because they are an unexpected choice. There are some distinct fields that, commercially at least, attract specialization, such as food, drink, jewellery, and fashion accessories.

Settings and backgrounds As every element in a still-life shot must be selected and planned, even the background has to be provided. It can vary from the simplest and blandest (plain white Formica or black velvet), through textured surfaces, to carefully constructed period sets. Some of the most common types of setting and background are:

☐ *White Formica* Smooth, without texture, strong, and re-useable (a standard item); backed up against a wall, it curves under its own weight to form a natural 'horizonless' scoop

☐ *Perspex* Very smooth, reflective, clinical, with a different appearance when front-lit or back-lit (if translucent, can also be lit from underneath); gives clean, sharp but subdued reflections

☐ *Glass* Similar effect to perspex, but needs backing for colour and density

The most complex of still-life settings can resemble entire room sets. In a case such as this, a re-creation of a seventeenth-century German apothecary's room, painstaking selection of props and set construction have been necessary in order to produce a convincing period atmosphere.

☐ *Black velvet* Absorbs light so well that it nearly always appears without texture; essential for pure black backgrounds

☐ *Stone* Slate and other rough stones have strong texture and massiveness, and can contrast well with delicate objects

☐ *Marble* Smooth, lightly patterned, good for shots of food being prepared

☐ *Wood* Wide choice of textures

☐ *Textured paper* One-time use, as it scuffs easily, but interesting range of textures, particularly the embossed varieties

☐ *Small sets* Basically, any collection of props, including furniture, that creates the atmosphere of another place or time

Lighting With such a wide range of subject material, there are few lighting techniques that could be called standard, certainly for the more imaginative still-lifes. However, a high proportion of straightforward still-life shots use a single, well-diffused light; a so-called window-light (see page 147) is probably the most widely favoured. This design of light is soft enough to make

shadows gentle, but is directional enough to be interesting. A single lamp, with white card reflectors to lighten the shadows opposite, has the extra virtue of simplicity, and this style of lighting draws little attention to itself.

Reflective objects like polished metal and dark glass are a special category, and make their own lighting demands. The basic problem is that they reflect their surroundings, which can be distracting and can confuse their shape. The chief cure is to use such a broad, diffuse light that its reflection covers most of the shiny surface. A cone or cylinder of tracing paper reaching from the lens to the object will give an almost complete reflection; this is known as a light tent. Whatever its shape, this diffusing material must have a smooth texture. Dulling spray is an alternative, but is not particularly elegant; it kills reflections, but at the same time changes the appearance of the object, sometimes completely out of character.

Transparent objects like glass are another special category, and the traditional technique is to back-light them. A refinement is to place black cards close to the edges of the glass, but still out of shot, to help define the shape.

Experiments There is more creative freedom possible in still-life photography than most people realize. For example, marrying two unlikely subjects in one image can have a surrealistic effect, or can even make a social comment; juxtaposition is, in fact, an important creative technique in illustrative still-life photography, such as for magazine covers.

Sequences of pictures in time, mosaics, and series of images with a linking theme (for instance, the same object with different treatments) are an alternative to the normal, single photograph. Interesting effects can also be produced with images that reverse the accepted norms of picture-making, such as sharp focus and conventional composition.

The rich, reflective properties of mahogany and brass in this old magic lantern have been exploited by using two large, diffused light sources, one for each face (above).

In order to light this rounded, shiny cowrie shell simply, without distracting reflections, but still retaining its reflective qualities, a sheet of tracing-paper was curved over it to diffuse the light and shape it to that of the shell (left).

Much less complicated than the setting on the previous page, but perfectly effective in creating the impression of contemporary surroundings, this simple location for a still-life of a piece of scrimshaw consists of no more than a painted chest and a whaling log (far left).

119

Aerial photography

A trip in a low-flying aircraft, and especially in a private small plane, is a marvellous opportunity for a completely different and fresh view of a landscape. If the lighting is right, there is every chance of several good pictures from a single flight.

Some of the most stunning aerial images – and the best can be startlingly unusual – are near-vertical views of strongly patterned subjects. By shooting downwards, the aerial photographer can cut out the horizon and so make the most of a dramatic camera position: there are some surprisingly graphic designs in both natural and man-made landscapes. The patterns of fields or housing estates, rock formations in a desert, or snow drifts accenting the contours of hills in winter, all make distinctive patterns from the air.

Clear, bright weather is the best general condition for photography, and the low sun of early morning and late afternoon gives strong local contrast, enhances the texture of the land, and picks out details to give a better impression of sharpness. Muggy, hazy weather looks much worse from a height than it does on the ground, making a photograph unreadable; for this reason, flying low with a wide-angle lens gives clearer results than a standard or telephoto lens from altitude.

Over towns and cities, large-scale features such as a harbour help to give structure to the view, even with a wide-angle lens, such as the 20 mm used here.

Pre-flight check
☐ (Private flight) Brief the pilot on what kind of subjects you are looking for
☐ (Private flight) For near-vertical shots, explain to the pilot that, on your signal, he should bank and circle to your side. Aircraft noise makes detailed conversation difficult in flight. If the pilot also throttles back as the aircraft slips sideways towards the subject, there will be less vibration
☐ (Private flight) Make sure that the windows will open (often only a screw holds the retaining bar)
☐ (Commercial flight) Try and book a window seat with a clear view (furthest forward is usually best) and on the side away from the sun when in flight (ask the crew)
☐ Have film and likely lenses laid out next to you, for quick changes

☐ Fit a UV filter to cut haze. A polarizing filter is even more effective, but needs more light, and the windows in some commercial aircraft may cause a rainbow effect

In-flight shooting
☐ Use as high a shutter speed as possible, preferably 1/250 sec or faster; depth of field is no problem, so the aperture can be wide
☐ Avoid touching the aircraft frame with the camera – it will transmit vibrations
☐ Open the window for shooting. Leave it shut for take-off and landing
☐ (Commercial flight) Be ready to shoot close to take-off and landing, when the aircraft is low, and particularly when it banks to your side, allowing shots downwards
☐ Shoot quickly when you have the chance

A medium telephoto lens, in this case 180 mm, gives the opportunity to look for small or unusual details that might otherwise pass unnoticed in the search for broader, panoramic views.

Even in landscapes that are lacking in obvious individual features, such as this tract of Amazonian rainforest, there are often patterns that can be used to strengthen the design.

Underwater

Underwater photography is possible at all levels of diving experience, and even shallow-water snorkelling offers plenty of good opportunities. Scuba is, of course, the ideal technique, not only because it makes it possible to dive deeper, but because it gives plenty of time to wait for and compose shots. Snorkelling is a good and inexpensive introduction to underwater photography, but dives are limited by the photographer's ability to hold his breath. Shallow reefs and static subjects (like sponges and corals) are ideal for snorkelling, but anything more ambitious needs tanks.

Natural light is essential for underwater landscapes, but its colour is increasingly blue with depth. This colour cast, and fairly slow shutter speeds, makes it useless for most close shots of fish, for which flash is virtually the only answer.

Diving tips
- ☐ Underwater, carry equipment on a strap; most cameras and flash are not buoyant
- ☐ Clear water makes a big difference to the pictures. Plan diving trips for the right season
- ☐ For the same reason, avoid violent finning close to the bottom as it will stir up sand and mud
- ☐ Protect your back and the backs of your legs from sunburn with either oil or light clothes
- ☐ When snorkelling, don't try to burst your lungs shooting several frames. Dive repeatedly, shooting once or twice at a time
- ☐ Belt-weights make you less buoyant and stop you drifting upwards when you have both hands on the camera; when snorkelling, however, be careful that they are not so heavy that they make it difficult to surface
- ☐ Snorkelling is easier at low water, as diving depths are shallower

Good diving sites There are one or two published guides to interesting diving sites in different parts of the world, and it is worth consulting them, as any diving trip benefits from careful planning. Clear water and good concentrations of animal life are

the main conditions for easy photography, and coral reefs are generally the richest locations. For gentle snorkelling, back reefs are shallow and usually free from turbulence, although the variety of life is rather limited.

In the middle of the day, under a
bright sun, even fine-grained
ISO 64 film can be used without
flash. At a shallow depth below
the surface, with a CC30 red
filter, this shot was taken at $\frac{1}{60}$
sec and f4.

35 mm lenses

Fish-eye Extreme curved distortion, particularly away from the centre of the image, is characteristic of fish-eye lenses. This permits a very wide angle of view, and can also be used for its graphic effect. They are generally most effective when used only occasionally, otherwise the distortion can become

6 mm

8 mm

16 mm

overpowering. Most give a circular image, but some fill the frame.

Wide-angle A short focal length gives a wide angle of view. It also gives great depth of field, making it possible to include close foreground and distance in sharp focus, and helping rapid shooting without critical focusing. Distortion, greatest near the edges, can be a problem with objects that have recognizable shapes (circles in particular), but can also make interesting compositions.

15 mm

24 mm

18 mm

28 mm

20 mm

35 mm

Standard A standard focal length gives a normal perspective. While lacking the graphic interest of very wide-angle and very long-focus lenses, it is the basic optical design. Wide maximum apertures (in the order of f1.2)

50 mm f1.2

50 mm f2

are easier to design for standard focal lengths.

Long-focus Long-focus lenses magnify the image, have a narrow angle of view, and shallow depth of field. They are useful for filling the frame with a subject that cannot be approached closely, and for compressing perspective. Focusing is always critical. Most long-focus designs are telephotos (allowing a longer focal length in a shorter barrel); an alternative is the catadioptric mirror lens, with fixed aperture.

85 mm

135 mm

105 mm

180 mm

200 mm

300 mm

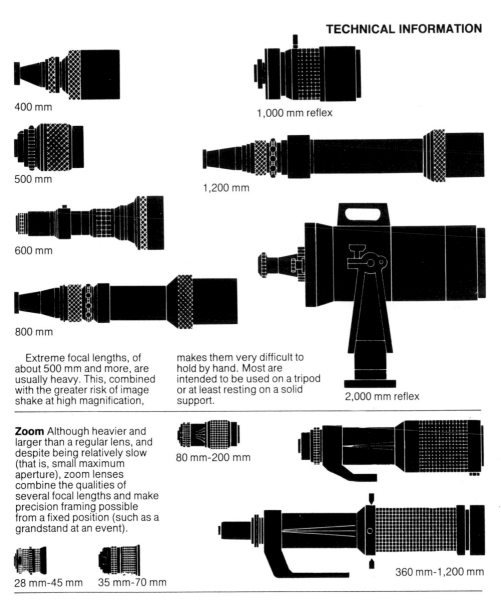

400 mm

1,000 mm reflex

500 mm

1,200 mm

600 mm

800 mm

2,000 mm reflex

Extreme focal lengths, of about 500 mm and more, are usually heavy. This, combined with the greater risk of image shake at high magnification, makes them very difficult to hold by hand. Most are intended to be used on a tripod or at least resting on a solid support.

Zoom Although heavier and larger than a regular lens, and despite being relatively slow (that is, small maximum aperture), zoom lenses combine the qualities of several focal lengths and make precision framing possible from a fixed position (such as a grandstand at an event).

80 mm-200 mm

360 mm-1,200 mm

28 mm-45 mm 35 mm-70 mm

Special Certain lenses are designed to deal with specific problems. Perspective-control (shift) lenses, which can be moved laterally in their mounts, can be used to keep vertical lines parallel in an image, useful in architectural photography. Night lenses have an expensively ground aspherical front element to reduce flare from points of light when used at the very wide maximum aperture. Macro lenses are best optically at short distances, medical lenses have a macro design and incorporate a ringflash. Autofocus lenses focus automatically.

28 mm perspective control lens

58 mm f1.2 Noct-Nikkor night lens

137

Rollfilm cameras

Camera bodies Standard rollfilm formats are 6 × 6 cm and 6 × 7 cm, although some smaller models give a 6 × 4.5 cm image and others give more panoramic views of 6 × 9 cm and even 6 × 17 cm (see pages 140-1). The inconvenience of non-reflex twin lens reflexes (TLR), needing pairs of matched lenses that are expensive and awkward to change, has made them almost obsolete; their role as mechanically simple rollfilm models has been taken over by compact rangefinder designs, some with special features such as shift movements (see pages 158-9). Nevertheless, the most common design is, as in 35 mm format, SLR.

These medium-format cameras are, in effect, a compromise between 35 mm and view cameras, giving a fairly large negative or transparency but being rather slow and awkward to use in any active situation. They are at their best in planned photography, such as studio portraits and fashion, and some landscape shots.

Single lens reflex
Hasselblad
500 C/M

Hasselblad
SWC/M

Hasselblad
500 EL/M

Pentax 6 × 7 cm SLR

Mamiya RB67

Twin lens reflex

Film backs Some rollfilm cameras have interchangeable backs (and therefore a second, focal plane, shutter), permitting rapid change from one film to another. These are available for 120 rollfilm, the longer lengths of 220 rollfilm, 70 mm sprocketed film, cut sheet film, and Polaroid film.

Sheet film holder

Standard back

70 mm film magazine

Polaroid film back

Lenses Although the sizes and focal lengths are different, the interchangeable lenses for rollfilm cameras such as the Hasselblad, Pentax, and Mamiya cover essentially the same range as those available for 35 mm cameras. As 'standard' focal length is normally calculated by measuring the film frame from corner to corner, for 6 × 6 cm cameras it is 80 mm, and for 6 × 7 cm cameras 90 mm.

80 m.m
standard lens

Fish-eye lenses The widest 6 × 6 cm format fish-eye lens has a 112° angle of view and gives a full-frame picture with characteristic barrel distortion.

30 mm wide
fish-eye

Wide-angle lenses For this format, 40 mm is extreme wide-angle, 50 mm and 60 mm regular wide-angle. Their uses and features are similar to the 35 mm format equivalents.

40 mm

50 mm

60 mm

Long focus lenses Extreme long-focus lenses are almost impossibly bulky for these formats, and the largest lens that is regularly available is 500 mm, equivalent only to about 300 mm on a 35 mm camera.

150 mm

250 mm

350 mm

500 mm

Zoom lenses Medium-format zoom lenses are as unwieldy as telephotos, and generally best on a tripod.

140-200 mm

View and special cameras

VIEW CAMERAS All these cameras take sheet film, which is loaded into dark slides. These fit behind the ground-glass screen, which is used for viewing. Additional film backs are available, to change film format, accept rollfilm and Polaroid film. The most commonly used formats are 4 × 5 in and 8 × 10 in.

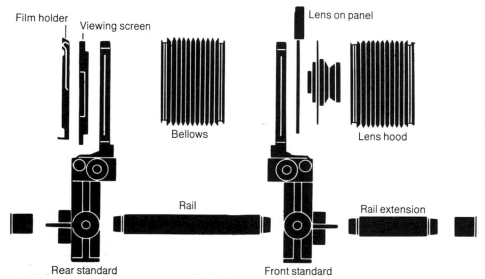

Film holder
Viewing screen
Lens on panel
Bellows
Lens hood
Rail
Rail extension
Rear standard
Front standard

Monorail This is the most precise of all the view camera designs. The front standard, carrying the lens panel, and the rear standard with the viewing screen and film back, run along a kind of optical bench which is mounted on the tripod or camera stand. The design is modular and flexible, giving extreme camera movements (see pages 158-9) and a wide choice of attachments and accessories.

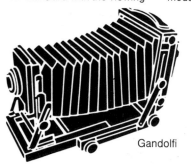

Gandolfi

Linhof
Technica

Field cameras One of the oldest designs of view camera has a flat bed as a base. Made largely of wood, and collapsible, it is convenient for location work and backpacking.

Technical camera Similar to a field camera in design, but more accurately engineered and more adaptable, the technical camera is intended for general large-format photography, both in the studio and on location. With a rangefinder and separate viewing system, technical cameras can be used hand-held.

SPECIAL-PURPOSE CAMERAS
Superwide and panoramic
For extremely wide angles of view, special cameras use either a very wide-angle fixed lens, or a mechanically driven rotating lens that projects its image through a slit. A long length of film is normally used for each exposure. One model rotates 360° for a complete all-round image.

Widelux

Sinar Handy

Amphibious For underwater photography, and also for wet weather on land, camera designs like the Nikonos use gasket seals known as O-rings to make the interior watertight. Alternatively, water-proof housings are available for most regular cameras. Some of the lenses specially designed for underwater refraction are not suitable for use in air.

Nikonos

Aluminium housing

High-speed The Hulcher is the best-known camera designed for photographing rapid sequences of action, and can operate at speeds of from five to 65 frames per second.

Hulcher 112

141

Exposure meters

Exposure meters measure either the light reflected from the subject towards the camera, or the light that falls on the scene. The first, known as a direct reading, is used by the TTL meters inside cameras, and in hand-held meters and spot meters. The second, an incident reading, is less commonly used, but can be made with most hand-held meters by fitting them with a translucent plastic dome and pointing them towards the light. The advantage of this method is that it is unaffected by the brightness of the subject.

All meters, however, work on the same principle: they average the different tones in the scene at which they are pointed, and give a reading that will result in a photograph that is mid-toned: a middle grey, or its equivalent in colour. The important thing in using an exposure meter, therefore, is to know exactly what part of the picture it is measuring.

TTL TTL meters are the most common, and most cameras incorporate them. Their great advantage is that they measure the exact image that is about to be recorded on film, and so are likely to be very accurate, even when lenses of unusual focal length are used. Rather than measure the entire frame, most are 'weighted' to compensate for the way that most people compose pictures. This is fine for average subjects, but when the background is very light or very dark, or when the composition is unusual, the reading may be inaccurate.

Most meter displays use a moving needle, glowing red light-emitting diodes (LEDs), or liquid crystal displays (LCDs). Automatic exposure in a camera simply links the reading to the shutter and/or aperture, effectively bypassing the photographer for speed and convenience. Most automatic exposure is aperture-priority, in which the photographer selects the aperture and the camera adjusts the shutter speed accordingly. Some cameras have shutter-priority, in which the shutter speed is chosen and the aperture adjusted automatically.

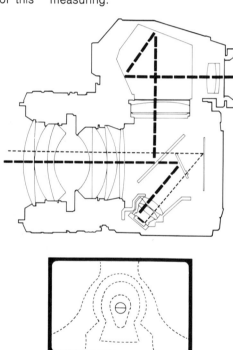

Hand-held Being separate from the camera, hand-held meters are slower to work with, but are very adaptable, and can usually take different attachments for making different types of reading, some as exotic as fibre optic probes. Most can also be used for either direct or incident readings. The angle of view that they measure is shown exactly through a viewfinder in some models, but for most it is more vague (approximately 30°, a little less than the coverage of a standard lens). They are good for unhurried photography, careful measurements, and to check the camera's own TTL system.

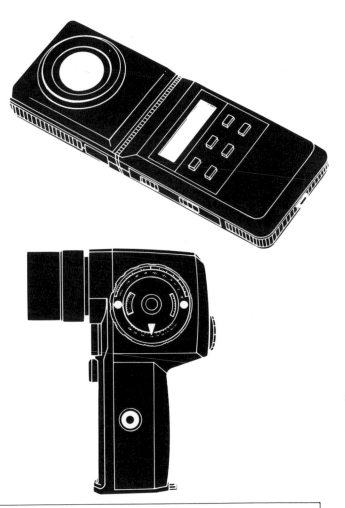

Spot Spot meters are hand-held, but are an accurate optical system that measures a precise 1° angle of view. They are ideal for measuring the exposure for very small or distant subjects, and for calculating the contrast range from highlight to shadow. For a craftsmanlike approach to photography, where tones have to be rendered precisely, they are invaluable, and are good for most difficult exposure systems.

Light-sensitive cells

Two types of light sensitive cells are used in exposure meters: selenium, which generate an electric current according to the amount of light falling on them, and battery-powered, which modify a small current passing through the cell. Selenium cells, needing no batteries, rarely fail, but as they are unreliable for readings in low light they are no longer widely used. Battery-powered cells are smaller and extremely sensitive, enabling readings to be taken in very low light conditions. There are three types: cadmium sulfide (CdS), silicon, and gallium, the last two being especially sensitive. The main problem with these cells is depleted batteries, and many modern cameras incorporate a testing device.

Portable flash

Dedicated flash The most advanced form of portable flash, dedicated units link up with the camera's electronic circuitry so that, according to the make, TTL flash metering is possible, the shutter speed is selected automatically, and the viewfinder display gives various kinds of information. As well as the camera companies themselves, independent flash manufacturers provide different shoe fittings to fit

various makes. A tilting head is important for bounce flash (upwards) and close-up

(downwards). Some flash units have interchangeable heads and diffusing attachments.

Automatic flash Adjusts exposure independently of the camera, by means of a photocell that measures returning light from the subject, and a fast-reacting thyristor circuit. The photo-cell can be fooled by foreground obstructions and close-up subjects. It is also adjusted for the high reflectivity indoors from ceiling and walls, and outside can give slight under-exposure.

Manual flash Very simple units that give one single output. Adjust the aperture according to the guide number of the flash.

Wet-cell The most powerful portable units use a wet-cell battery. Bright but cumbersome.

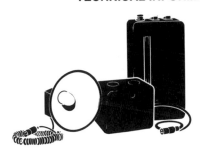

Fast re-cycling Some units, such as the Norman 200B, recharge quickly, which is useful for fast-action photography.

Ringflash Designed for shadowless close-up photography, ringflash heads attach to the front of the lens. They are not powerful enough for shooting at more than 3 feet or so with regular colour film.

Close-up bracket These are various mechanical methods of positioning one or two small units close to small subjects.

Photo-cell slave trigger Synchronizes a second flash unit by reacting to the first pulse of light.

Sync junction For connecting two or more units together. WARNING: can damage the camera's circuitry if different types of flash unit are connected together. A photo-cell trigger is safer.

Flash bulbs More primitive than electronic flash, but fairly fool-proof. Very adaptable, as all they need is a small current to trigger them. The largest bulbs are very powerful, and useful for lighting large areas where there is no mains electricity (guide numbers in the region of 220 are usual).

Photographic lighting

Flash power units High-output studio flash needs large capacitors, and the traditional system has these in power units that are separate from the heads. The large unit at the immediate right supplies 5000 Joules, the smaller 1000 Joules, while the booster improves recycling time. A more recent, compact design integrates the head with the power pack.

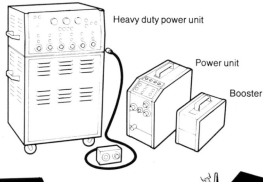

Heavy duty power unit

Power unit

Booster

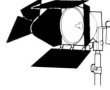

Quartzlight

Softlight

Totalite

Fresnel luminaire

Tungsten lamps Most photographic tungsten lamps produce 3200K light, and the most efficient designs have a quartz-like envelope filled with a gas (such as halogen) that prevents re-depositing of the burnt element. Most lamps need attachments to modify the light, but softlights and Fresnel luminaires have built-in diffusion and concentration respectively.

Flash tubes Flash tubes are generally ring-shaped, coil-shaped (for high output), or linear (in strip-lights).

Coil head

Bowens Monolight (integral)

Snoot Lensed spot

Shallow bowl reflector

Deep bowl reflector

Head attachments
Photographic lamps are rarely used unmodified. The basic attachments either concentrate the light (i.e. snoots and lensed spotlights) or diffuse it. Barndoors shape the way the light falls, and prevent unwanted spill.

Diffusers: Opal Gauze Honeycomb Scrim Half scrim

Dished bowl

Window light

Barndoors

Umbrellas Reflectors if
opaque (white, silver or gold
inside), diffusers if translucent.
Sizes vary; shape is round or
rectangular. The standard
portrait attachment.

Area lights These are
enclosed boxes fronted with a
translucent material such as
opal perspex/plexiglas. The
lighting effect is diffuse, but
more directional than that of an
umbrella. The precise shape
and even area of light make
them ideal for shots where
their reflection will appear.
Being enclosed, area lights are
not suitable for tungsten
lamps, which would overheat.

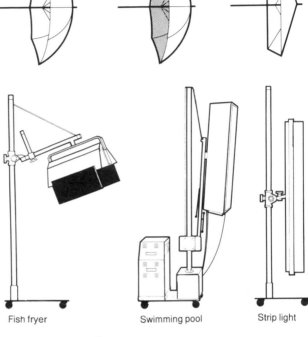

Fish fryer · Swimming pool · Strip light

Extension drum cable

Portable power generator A
gasoline generator is the most
satisfactory solution to outdoor
location sets that require
powerful photographic lighting.
2kW or 3kW is normal.

Portable lights For regular
location work indoors, or close
to a mains supply, some studio
lamps are supplied as a
portable set with carrying case.

**Battery-powered tungsten
lamps** Designed specifically
for movie and video location
shooting, these small hand
lamps have uses where
continuous light is needed far
from a mains supply.

147

Free-standing reflectors and diffusers Large sheets such as these are highly adaptable, inexpensive, and suitable for broad modification rather than precision lighting. Efficiency ranges from Mylar (hard, mirror-like reflection) to polystyrene (soft and diffuse). Both polystyrene and corrugated plastic combine lightness with rigidity.

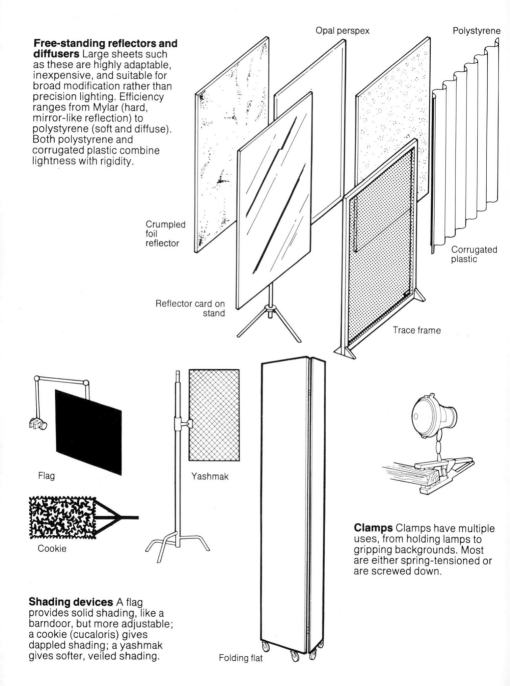

Opal perspex

Polystyrene

Crumpled foil reflector

Corrugated plastic

Reflector card on stand

Trace frame

Flag

Yashmak

Cookie

Folding flat

Clamps Clamps have multiple uses, from holding lamps to gripping backgrounds. Most are either spring-tensioned or are screwed down.

Shading devices A flag provides solid shading, like a barndoor, but more adjustable; a cookie (cucaloris) gives dappled shading; a yashmak gives softer, veiled shading.

148

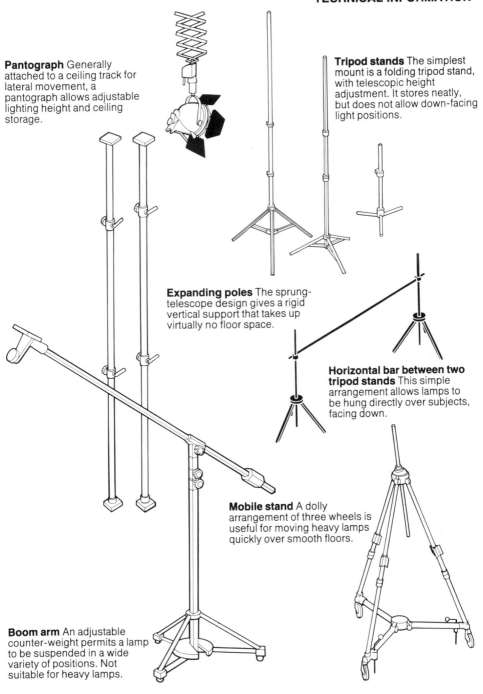

Pantograph Generally attached to a ceiling track for lateral movement, a pantograph allows adjustable lighting height and ceiling storage.

Tripod stands The simplest mount is a folding tripod stand, with telescopic height adjustment. It stores neatly, but does not allow down-facing light positions.

Expanding poles The sprung-telescope design gives a rigid vertical support that takes up virtually no floor space.

Horizontal bar between two tripod stands This simple arrangement allows lamps to be hung directly over subjects, facing down.

Mobile stand A dolly arrangement of three wheels is useful for moving heavy lamps quickly over smooth floors.

Boom arm An adjustable counter-weight permits a lamp to be suspended in a wide variety of positions. Not suitable for heavy lamps.

149

Supports

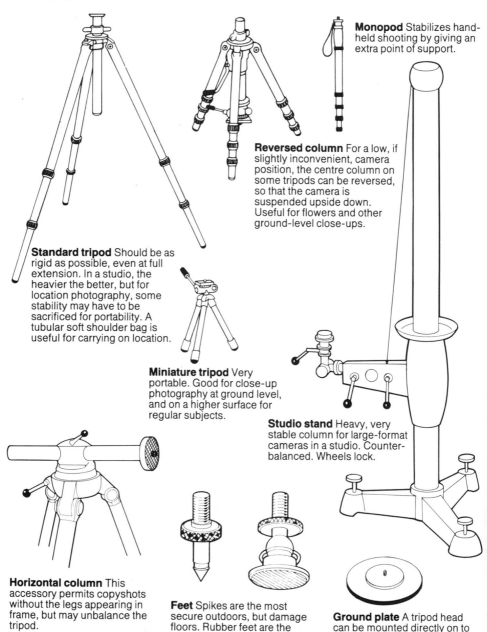

Monopod Stabilizes hand-held shooting by giving an extra point of support.

Reversed column For a low, if slightly inconvenient, camera position, the centre column on some tripods can be reversed, so that the camera is suspended upside down. Useful for flowers and other ground-level close-ups.

Standard tripod Should be as rigid as possible, even at full extension. In a studio, the heavier the better, but for location photography, some stability may have to be sacrificed for portability. A tubular soft shoulder bag is useful for carrying on location.

Miniature tripod Very portable. Good for close-up photography at ground level, and on a higher surface for regular subjects.

Studio stand Heavy, very stable column for large-format cameras in a studio. Counter-balanced. Wheels lock.

Horizontal column This accessory permits copyshots without the legs appearing in frame, but may unbalance the tripod.

Feet Spikes are the most secure outdoors, but damage floors. Rubber feet are the most generally useful.

Ground plate A tripod head can be mounted directly on to this steel plate for a low view.

Heads The stability of a tripod depends heavily on the strength of the head. Most heads are variations on two designs – ball-and-socket, which allows complete freedom of movement but is difficult to adjust delicately, and pan-and-tilt, which separates movement into three axes. A half-tightened head can be used for following movement with a heavy lens.

Ball and socket head

Pan and tilt head

Clamps Spring-loaded or screw-tightened clamps can be fixed to tables, railings, or any existing solid object in place of a tripod.

Crow's feet

Weighting Any weight pressing or pulling down on the centre of the tripod holds it more steady. A spreader locks the feet on a flat surface. On location, a string bag can be filled with rocks.

Tying down Drive a spiked or screw-threaded ring into the ground or wooden floor, attach a rope or cord as shown, and tighten with a stick. The tension improves rigidity. Wooden blocks, known as crow's feet, can be nailed or pegged down to hold the legs securely.

Studio accessories

Backgrounds A selection, for
both portraits and still-life,
including sheets of perspex
(opal and coloured), Formica,
wood, mylar, vinyl

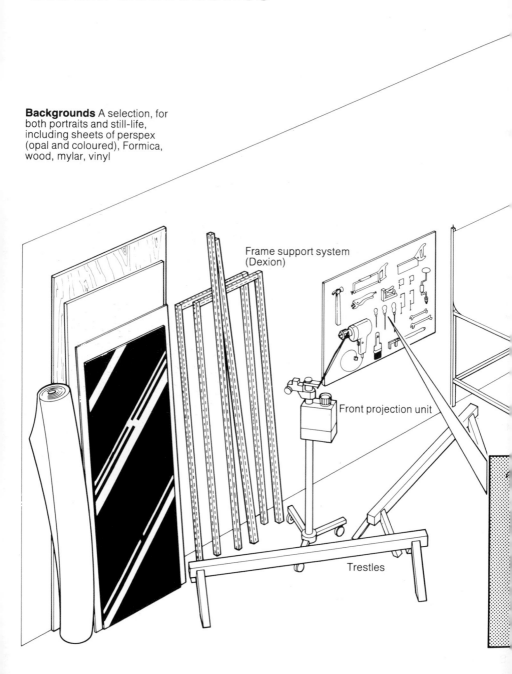

Frame support system
(Dexion)

Front projection unit

Trestles

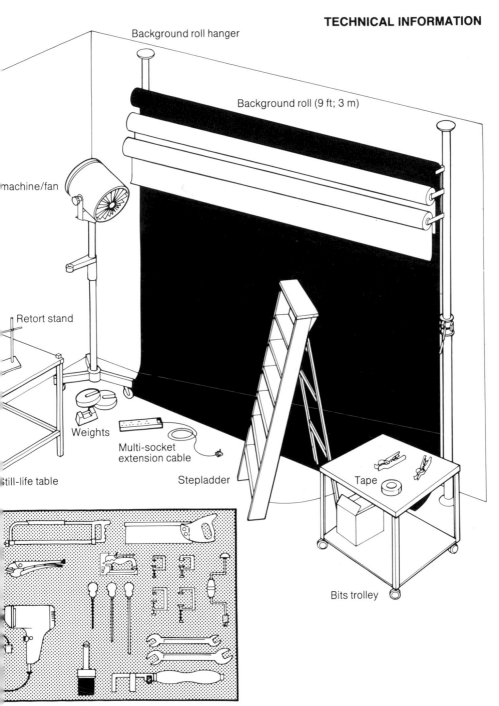

Background roll hanger

Background roll (9 ft; 3 m)

machine/fan

Retort stand

Weights

Multi-socket
extension cable

still-life table

Stepladder

Tape

Bits trolley

Staple gun and other tools, on pegboard

Focus and frames

Lenses are focused by moving either all or some of the elements backwards or forwards. Close to the film, the lens is focused on infinity; further forward it focuses on closer distances. The traditional system uses a helical screw, but newer lenses focus internally so that the lens barrel itself does not change in length. With view cameras, the bellows are stretched or squeezed to focus.

SLR focusing Visual focusing through a prism on to a ground-glass screen is the most straightforward way of judging focus, and all SLRs use it. Different screens, such as those shown (right), can sometimes be interchanged to suit individual preferences and different situations. Most SLRs show slightly less than the full image to compensate for framing mistakes.

□ *Plain ground glass* Shows fine detail and allows fine focusing, but the image appears dark at the edges

□ *Fresnel screen* A flat screen of concentric rings sandwiched to the ground glass; brightens and evens the image, but is slightly more difficult to focus.

□ *Split prisms* Two small central prisms split the image when out of focus; needs to be focused on an edge of the subject, and is no use at small apertures or with extreme focal lengths

□ *Microprism* An over-all pattern of small prisms that work in a similar way to split prisms but without needing definite edges to focus on; the image appears scrambled when out of focus

Rangefinder focusing For non-reflex cameras, a rangefinder uses two viewing windows to give something similar to binocular vision. A ghosted secondary image appears in the viewfinder until the focus is properly set.

Automatic focusing Some cameras focus automatically on whatever is in the centre of view. One system uses a sonar pulse, another uses a bounced infra-red beam, while another judges the degree of contrast (there is more contrast in a sharp image than in a soft one).

Plain ground glass

Fresnel screen

Split prism

Microprism

Rangefinder focusing

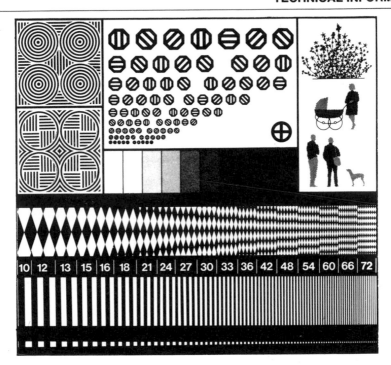

Lens test target This test target is designed to check the performance of lenses at resolving detail. Use fine-grain film and photograph the target at a distance that is 40 times the focal length of the lens (that is, 4½ feet (1.4 metres) with a 35 mm lens, 6½ feet (2 metres) with a 50 mm lens, or 10 feet (3.2 metres) with an 80 mm lens). Make several exposures at different apertures.

Examine the negative or transparency with a magnifying glass to see how far along the scale the black-and-white lines remain distinct. At the point where they begin to merge together, the figure alongside (underneath) gives the resolving power of the lens, in lines per millimetre.

Focus shift with special glass Some high-quality glasses used in expensive long-focus lenses expand or contract slightly if the temperature changes. For this reason, the distance scale engraved on the lens is only an approximate guide. Always check infinity focus visually.

Infra-red focus Infra-red wavelengths, to which infra-red film is sensitive, are so much longer than visible ones that they focus *behind* the sharp focus that is actually visible. Visual focus will render an infra-red image soft.

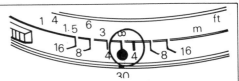

Either use the red mark engraved on the lens barrel to focus against, or else move the lens *forward* from its visual focus by ¼% of its focal length (e.g. 0.5 mm for a 200 mm lens). Some special glasses, however, give such good correction that no adjustment is necessary.

155

Depth of field

When a subject is sharply focused, anything closer to or further away from the camera will be less sharp in a photograph. However, for perhaps a small distance either side, the image will be *acceptably* sharp. This zone of reasonable sharpness is the depth of field, and it is subjective – in other words, it depends on who is looking at the image.

For most purposes, though, focus is considered sharp as long as points appear as points rather than as small circles, which they do when they are not sharp. The smallest circle that most people can distinguish unaided measures about 0.033 mm across, and this is known as the circle of confusion. Most lenses are judged professionally on this standard.

The most important effects on depth of field are:

□ *Focal length* Long-focus lenses have less depth of field than wide-angle lenses (which have short focal lengths)

□ *Focusing distance* There is less depth of field when the subject is close

□ *Aperture* The smaller the aperture, the greater the depth of field. Fast lenses used at their widest aperture have very little indeed

□ *Lighting* Lack of sharpness is less noticeable in flat lighting, so depth of field may seem slightly greater

Choosing depth of field Because sharpness is one of the traditional virtues of photography, there are usually more occasions when the depth of field needs to be improved than otherwise. There are, however, some specific reasons for wanting very little depth of field; the most common are given on pages 64-5.

Calculating depth of field The depth of field in any particular situation can be worked out as follows:

□ *Visual check* With an SLR, press the pre-view button with the lens stopped down to the aperture that will be used. Viewing may be difficult in dim light or at a very small aperture. In the studio, particularly with a view camera, a small flashlight can brighten parts of the image you are checking

□ *Lens scale* Marked on the barrel, this gives the *manufacturer's* idea of acceptable depth of field

□ *Depth of field table* Usually supplied with each lens. Very slow to use

□ *Formula* Assuming the 0.033 mm circle of confusion that is standard in the industry, the nearer limit of the depth of field measured from the sharp

$$\text{focus} = \frac{00 \times \text{focused distance}^2}{\text{effective diameter} + \text{focused distance of lens}},$$

and the farther limit $= \dfrac{00 \times \text{focused distance}^2}{\text{effective diameter} - \text{focused distance of lens}}$

$$\left(\text{effective diameter of lens} = \frac{\text{focal length}}{\text{f-stop}}\right).$$

Adding the two together gives the total depth.

□ *Rough guide* To make the best use of whatever depth of field exists, focus one-third of the distance into the subject. With close subjects, however, focus at the mid-point

Hyperfocal distance To keep as much as possible sharp including the horizon (usually important for landscapes), focus the lens on what is known as the hyperfocal distance. At this point, the far edge of the depth of field just reaches infinity. The illustration (below) shows how.

With the lens focused at infinity, two-thirds of the depth of field here is wasted (left). By turning the focusing ring so that the infinity ∞ mark lies against the edge of the depth of field on the lens scale, the image is sharp all the way from infinity to 30 m (right). Hyperfocal distance varies according to the aperture.

Camera movements

Moving the lens and the film in relation to each other alters the image in several ways. Most small-format cameras have fixed bodies, and their only camera movement is focus. View cameras generally have these others: shift, tilt and swing. Depending on whether it is the lens panel or the film back that is moved, these movements can alter the perspective, the distribution of sharpness, and the shape of the image.

To make use of movements, the body of the camera is flexible in some way, and the lenses cover a much larger area than the film frame. Limited movements are possible with a few smaller-format cameras.

Shifts Sliding the lens panel up, down, or sideways moves the whole image, so that a different part of it is projected on to the film. Shifting the film back has the same effect. With architecture, an upward shift (rising front or falling back) makes it possible to include the top of a tall building in shot without tilting the camera (see pages 86-7). In a still-life shot, the positions of objects can be altered in the image without changing the perspective.

Both lens panel and film back can be moved together in opposition for a more extreme shift, although poor image quality near the edges of the coverage of the lens sets the limit.

Tilts and swings In a fixed-body camera, the lens axis is perpendicular to the film, and the plane of sharp focus is parallel to the film. In other words, if the camera is aimed horizontally, the sharpest part of the image is like a large flat sheet facing the camera. Tilting the lens panel or the film back up or down, and swinging either sideways, changes all this, and with skilful use, the plane of sharp focus can be made to lie anywhere. As the illustrations (below) show, this has the advantage that the important parts of the image can be focused sharply together even at a wide aperture.

Moving the lens panel changes only the distribution of sharpness. Moving the film back does the same, but also distorts the image, which can be useful for exaggerating shapes or for correcting them.

To change sharpness and shape: tilt or swing film back

To change sharpness only: tilt or swing lens panel

Tilting or swinging the film back, then adjusting the lens until it is parallel to the film, changes shape without affecting sharpness distribution.

All the important detail in this fossil beach lay in a horizontal plane. Tilting the lens panel forward brought the whole scene into focus, so that sharpness extends from the far distance to just inches from the camera.

Acknowledgements

Keith Johnson Photographic
Limited
Paulo Colour Lab
Polaroid (U.K.) Limited
Kodak Limited